How to Paint
ANIMALS

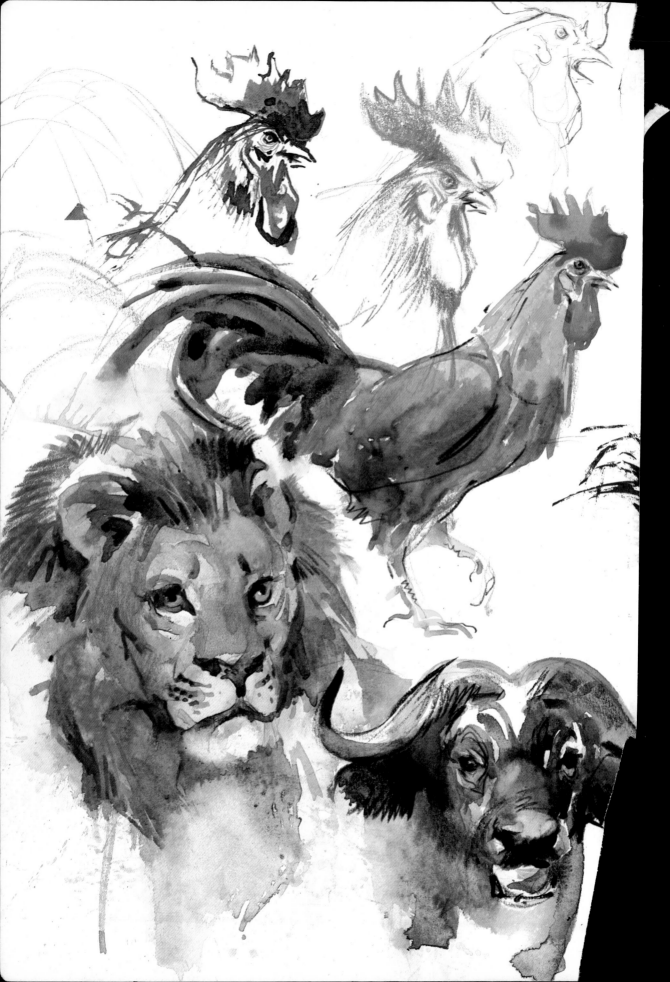

How to Paint
ANIMALS

by José M. Parramón and Vicenç Ballestar

**The history of animals in art;
their anatomy and basic structure;
techniques for making quick sketches;
and the materials for and practice of drawing
and painting animals.**

Watson Guptill Publications/New York

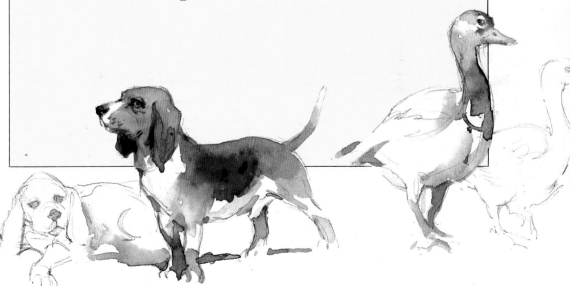

Contents

Introduction

Fig. 1. Vicenç Ballestar, *Horse Rearing*. This pen and ink drawing demonstrates the artist's complete identification with the horse and with the animal world in general.

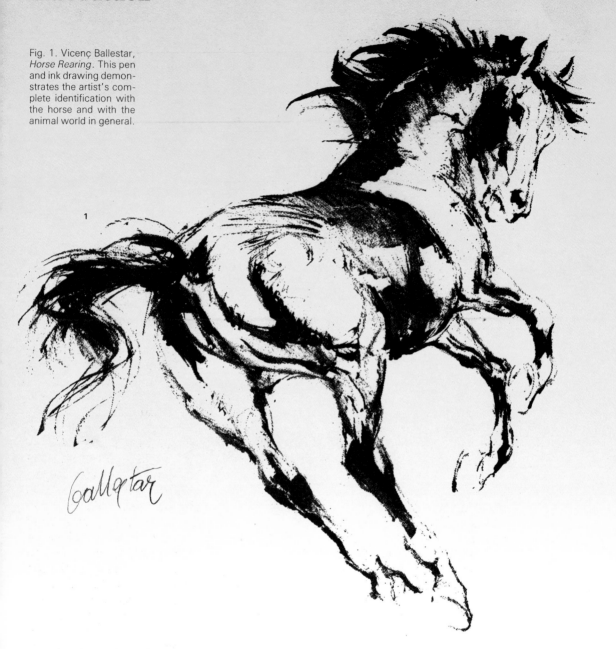

Yeh Tsui-pai, born 80 years ago in China, is one of the best-known Oriental artists in the West. He always paints horses—"I would not change this subject for any other," he says—and his sumi ink paintings are sold for excellent prices. A few months ago, he presented an exhibition of his work in Amsterdam, Netherlands; Bonn and Düsseldorf, Germany; and Madrid, Spain. Asked by a journalist why he dedicated his work exclusively to painting horses, Yeh Tsuipai replied, "Because I am the horse."

Vicenç Ballestar, my co-author in this book, could say the same thing about himself regarding the horse, the dog, the cat, and the bird. In the same way as the Chinese artist, Ballestar feels a special love for animals. He identifies with them, knows and understands them, and is greatly attracted by the idea of capturing this living thing—the animal resting, walking, running, or jumping. "I'm in my studio and I see a pigeon on the terrace, and I draw a sketch. I see a cat walking over the roofs, or I see two

mounted police on their horses passing by in the street, and I can't resist the idea of drawing them.''

Ballestar and I worked together for just over a year in order to publish this book. Ballestar sketched, drew, and painted while I encouraged him and took notes, trying to explain what Ballestar does and what you should do in order to be able to draw and paint animals at home, on the farm, or at the zoo.

I must confess that the first time we worked together—when Ballestar was sketching, drawing, and painting his daughter's pet dog Escarlata, which we will see later on in this book—the first thing that I thought to myself was that the ability to draw and paint animals was an exceptional gift, something that not just anyone can do. You would have to see how Ballestar works for yourself to understand what I felt. Imagine an animal, any animal, restless, forever moving around, and Ballestar with his notebook and pencil in hand. He takes his time and spends five or six minutes looking at the animal, studying it. Then suddenly he starts to draw the outline of the head, the back, the nose, all the time looking from the paper to the animal and back again. The animal is moving about all the time, of course, yet Ballestar draws firmly, with no mistakes and no erasures as the dog, the cat, the horse, or whatever he is drawing begins to appear on the paper as if by magic! That's impossible, of course, I thought to my-

self. Who can hope to draw a subject that constantly wanders about like this? After much thought on the subject, I found the answer to this problem.

''Could I draw a human figure from memory?'' I asked myself. Yes, of course I could, and so could anyone who has drawn a human figure in real life, nude or dressed, as many times as I have. Professional artists who draw comics almost always draw figures from memory, and, at times, in the most unusual positions. So it can be done, especially if the artist can refer to the model in front of him to verify distances and proportions.

Therefore, you too can draw and paint animals, even if they do move! But you must be willing to draw many animals many times, until you have memorized forms and outlines, the head structure of the dog, the cat, the horse; the particular composition of front and hind legs, which is similar in all these animals; and the synthesis of form in the bird. We two will help you, Ballestar by drawing and painting and I by explaining and writing. With illustrations and words, we will introduce you to the basics of drawing animals, including basic anatomy, light and shade, of value, contrast, and color. We will explain the techniques of the quick sketch, and we will take you with us to draw from real life at the zoo and on the farm. But, in the end, it will all depend on you: your willpower and enthusiasm; your desire to draw many, many sketches of animals; your willingness to learn and memorize their forms, poses, and movements ... until you too can declare, with Yeh Tsui-pai and Ballestar, ''I am the horse!''

José M. Parramón

Figs. 2 and 3. The authors of this book, Vicenç Ballestar (on the left) and José M. Parramón. Ballestar is our guest artist, and Parramón is the writer of the text.

2

3

Ballestar said to me, "Man is a hunter by nature, and the first thing he really drew was the animal. If you think about it, in the rock paintings in the Altamira and Lascaux caves, the figures of women and children are just stick drawings, but the bison, the deer, the bulls, and the horses are painted with an extraordinary realism and artistic quality." It is true, and this artistry in drawing animals has remained a constant throughout history, from the times of the Egyptians to the baroque and Renaissance periods right down to the present day. Many artists have dedicated special attention to drawing or painting animals, artists such as Rubens, Rembrandt, Stubbs, and Degas.

Over the next few pages, we will talk about these and other artists, trying to briefly summarize the history of the art of painting animals.

THE HISTORY OF PAINTING ANIMALS

A short historic summary with illustrations from universal masterpieces.

Prehistory, Egypt, Greece, Rome

Traces of prehistoric paintings have been found that go back as far in time as the origins of mankind itself. Many of these paintings depict wild animals and are found in obscure and inaccessible caves. Some of the oldest examples are located in places that were not necessarily the habitual dwellings of the people of those far-off times. Mankind, then, ever since he began to create art, has painted animals—his companions, his allies, his enemies, his food, his necessity. These rock paintings were probably used to make magic, to procure success in the hunt.

Man evolved, becoming a farmer, building settlements, establishing different cultures, but still portraying animals in his art. In Egypt, where a great civilization flourished for thousands of years, animals were depicted on papyrus, in the pyramids, and on the stone coffins. For instance, the wild ducks in Fig. 7 reveal a special sensitivity to the activities of animals.

In Crete, the great palace of Knossos was a cornerstone of Greek and Roman culture, and therefore of our Western culture. Frescoes such as the dolphins shown in Fig. 8 have been discovered there. Richly colored and full of movement, these frescoes demonstrate the direct observation of animal life on the part of the Cretans.

This same attention to detail is to be appreciated in the clay vessels of the ancient Greeks and in the mosaics and frescoes of the Romans (Figs. 9 and 10). We can conclude from observation of all these remains of ancient art that there is an important common factor in all their portrayals of animals: The animal was used to express or even influence the hidden forces of nature. The painting of animals had a magical or religious function, to a greater or lesser degree depending on the particular culture and age. This did not, however, represent an obstacle to a practical, firsthand relationship with animals, or a perfect knowledge of their form of life, which are perfectly portrayed in these ancient art forms.

Fig. 4 (previous page). Hokusai, *Birds Flying* (detail). Uffizi Gallery, Florence. The portrayal of animals has always been a favorite theme of Oriental artists, many of whom become specialists in drawing or painting one particular species and achieving great heights of perfection.

Fig. 5 (previous page). Peter Paul Rubens, *Study of Cows* (detail). British Museum, London. Rubens's magnificent gift of observation and his enormous talent for capturing form in his drawing are apparent both in his studies of human figures and in his drawings of animals.

Fig. 6. Painting in manganese and ochre of a bison. Altamira Cave, Santander, Spain. Most of the traces of prehistoric art that have survived to the present day show animals as a central theme. This is because the hunt was the central activity of primitive man.

6

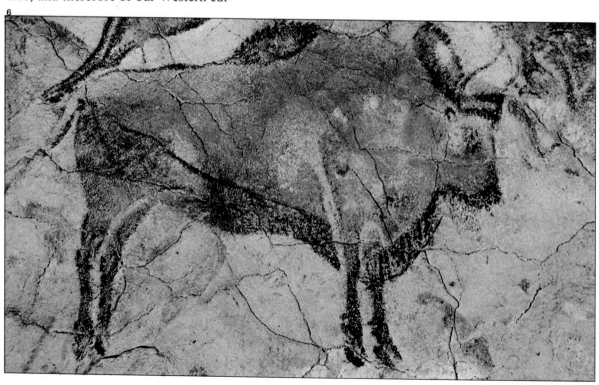

7

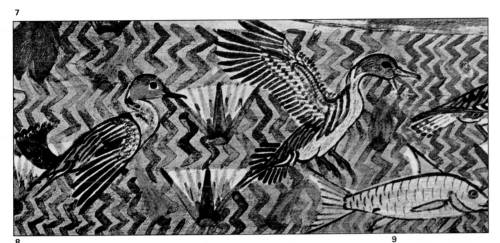

Fig. 7. *Hunting and Fishing: Wild Duck.* Tomb of Mena, Thebes, Egypt. Egyptian painting, often rigid and conventional when dealing with human subjects, took a great delight in the naturalist description of animals. These splendid paintings are full of life and movement.

Fig. 8. Fresco of the Dolphins of Knossos. Herakliton Museum, Greece. The frescos of Knossos, are the finest illustration of Mediterranean art.

8

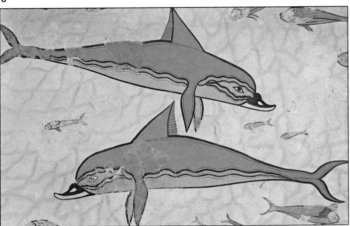

9

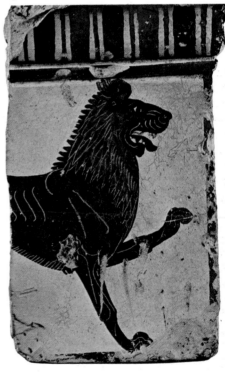

10

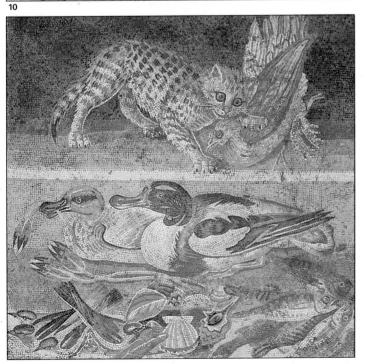

Fig. 9. Portable altar, second half of the sixth century B.C., Museum of Corinth. Animals were frequently represented in primitive Greek art. The force and energy expressed in this painting of a lion is transmitted through an austere use of materials, a black silhouette over an ochre background.

Fig. 10. Roman art, cat eating a partridge, and wild ducks. Museo Nazionale, Napoli. The mosaic was the most popular medium for decorating the interiors of buildings in ancient times. This example shows the remarkable likeness that the artists of early history were capable of achieving.

The Middle East and Far East

In both the East and the West, spirituality in the form of religion or magic is found at the root of artistic development. In the East, two important though very different religions, Islam and Buddhism, played a large role in the evolution of thought and in the aesthetic theory of the different religions of the area. The Islamic religion prohibits the portrayal of images that have religious significance, so the artists of the Islamic world had to turn to the illustration of novels, stories, and fables, producing marvelous miniatures in which animals very often figured. There are horses and elephants in the stories of battles; oxen, monkeys, lions, and birds in the fables; all of them stylized elegantly and decoratively, but still answering to a natural, real, firsthand vision of the world.

Another outstanding quality common to these pieces, whether from India, Persia, or Turkey, is their magnificent, sumptuous use of color. In China and Japan, the Buddhist religion and others derived from it considered all painting, poetry and music an act of meditation or contemplation. The artists, who painted mostly landscapes and animals, concentrated all their delicate skills in the precision of each brushstroke, to express their wonder and awe at the perfection of the world around them. The results are of astounding beauty, decorative and naturalistic to the point of being able to depict the flight of a bird with the most superb realism.

Fig. 11. *The Bull Shanzebeh in the Pasture.* Galistan Library, Tehran, Iran. The delicate and enormously refined miniatures of Persian art reveal an aristocratic culture of sophisticated tastes. This figure of a bull shows a delight in arabesque designs, typical of the Oriental world.

Fig. 12. Hokusai, *Birds Flying.* Uffizi Gallery, Florence. The prolific Japanese artist Hokusai had a considerable influence on the French artists of the nineteenth century, who saw in his art a magnificent capacity to synthesize natural forms through a great simplicity of technique.

11

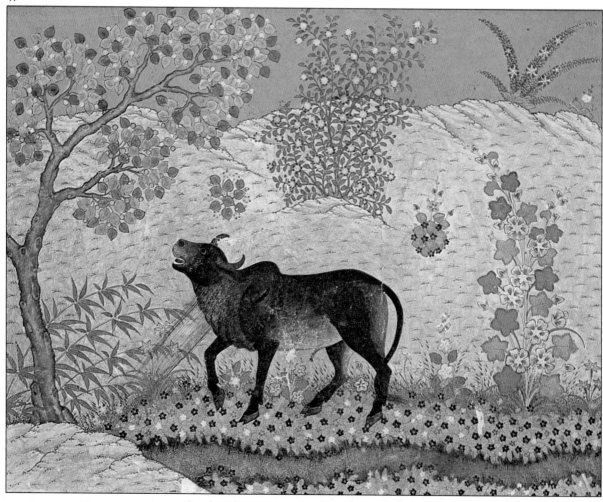

12

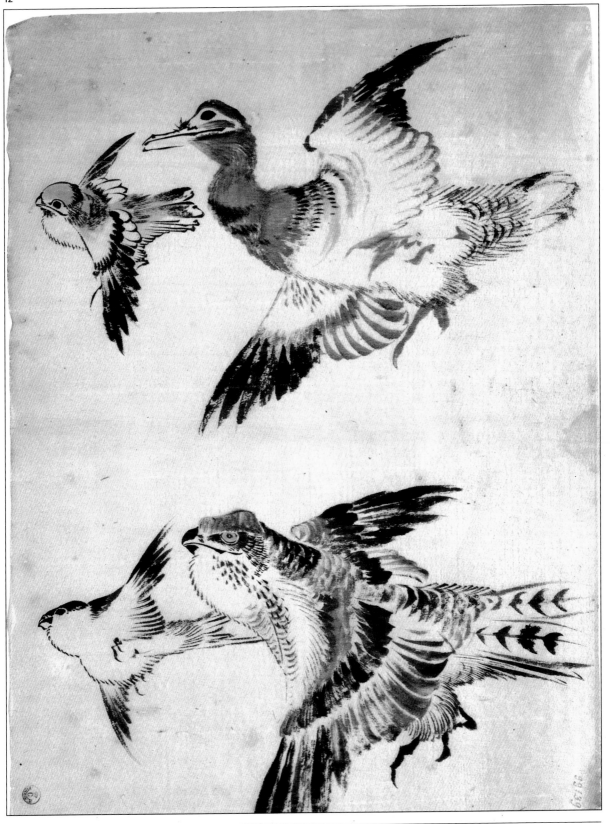

The Middle Ages and the Renaissance

In the early Middle Ages, Christian artists used the animal in their work. The bestiaries of the time, for instance, are symbolic of another reality, and particularly of the moral vices and virtues. In the Renaissance, however, artists began to feel a great curiosity for nature, wanting to know what it was like inside and outside, and to depict the relationships between man and the animals, as a result of the new vision of man as the center of the universe. At the same time, Renaissance artists were attracted to the decorative qualities of animals, feeling themselves to be the direct heir of the Greek concept of beauty. For all these reasons, the animal once again came to be portrayed as it was and not as a sym-

13

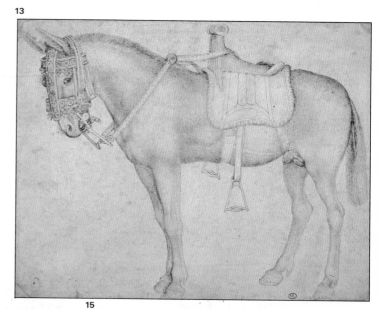

14

15

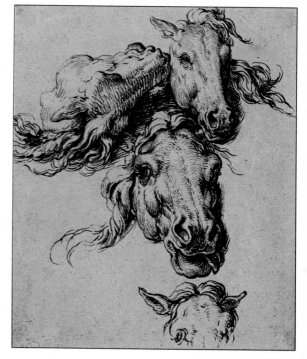

bol of moral or mystical ideals. The point of view of the Renaissance artist is practically the same as the one that has come down through history to our own times.

The study of animal anatomy, both for its own sake and as a way of knowing man better, became necessary. A scientific approach and the precision of naturalism were characteristic qualities of such great artists as Leonardo in Italy and Dürer in Germany.

16

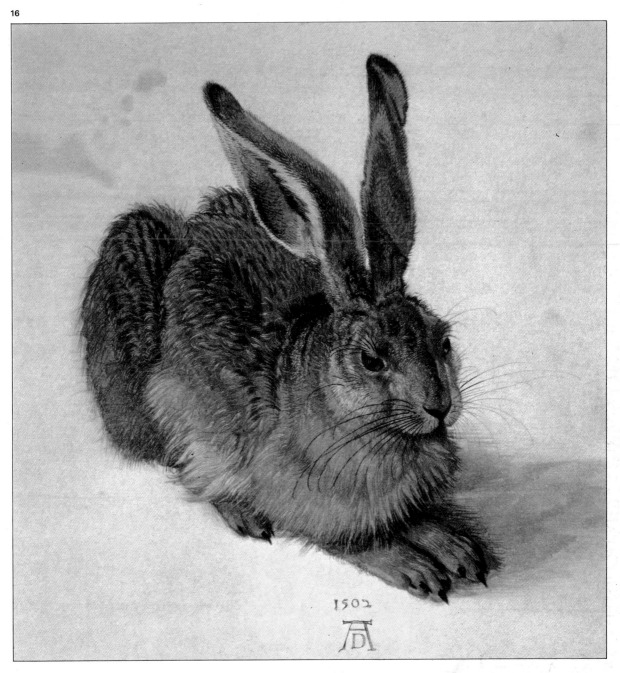

Fig. 13. Antonio P. Pisanello, *Mule*. Louvre, Paris. The fourteenth-century artist Pisanello is particularly renowned for his drawings and paintings of animals. This drawing of a mule is surprising for the loving care with which the artist has reproduced every muscular mass. One can also perfectly imagine the softness of the animal's coat.

Fig. 14. Paolo Ucello, detail of *Saint George and the Dragon*. National Gallery, London. Warriors on horseback were a favorite theme in Ucello's work, which combined a fondness for the effects of perspective and an elegant portrayal of animals. This firm, strong beast reminds one of the grace of the animals on a merry-go-round at the fair.

Fig. 15. Jacques de Gheyn II, *Four Horses' Heads*. Kupferstich-kabinett, Berlin. Best-known as an engraver, de Gheyn's sinuous lines and the accumulation of volumes reveal his sophisticated mannerist tendencies.

Fig. 16. Albrecht Dürer, *Hare*. Albertina Library, Vienna. This famous watercolor shows Dürer's passion for detail and his determination to depict nature with the utmost accuracy, which surprised even the Italian artists of the Renaissance.

The baroque period

Other themes were soon added to the desire to portray the familiar animals of the farm and the pets popular with the middle and merchant classes. The hunt had become a popular sport, particularly in England, and the dog and the horse were increasingly important as subject matter for art. In fact, the horse is the animal most frequently depicted since prehistoric times. Besides this, the expeditions of scientists and tourists and the occupation of new lands gave more Europeans firsthand knowledge of exotic animals such as the lion, the giraffe, the rhinoceros, the elephant, and the camel. These animals became more popular in art, partly through the need for correct scientific documentation and partly as the protagonists of battle scenes or illustrations for the Bible.

Both Rembrandt and Rubens drew lions, elephants, and tigers, at rest or attacking their prey; Europeans hunted these animals and brought them back to their homelands. These drawings are full of fantasy, with free, vibrant lines, being taken from real life and later used as a reference for grand paintings.

17

18

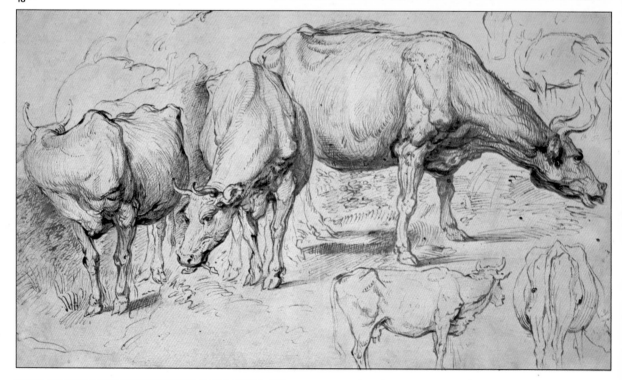

Fig. 17 (opposite page). Diego Velázquez, *Portrait of Prince Felipe Próspero* (detail). Kunsthistorishes Museum, Vienna. The ''impressionist'' realism of Velázquez could be biting in some of his portraits of kings, but he reserved touches of charm and delicacy for figures such as this dog.

Fig. 18 (opposite page). Peter Paul Rubens, *Study of Cows*, British Museum, London. The fact that many drawings by Rubens have been preserved reveals the importance he placed on making studies of natural forms before actually painting them.

19

20

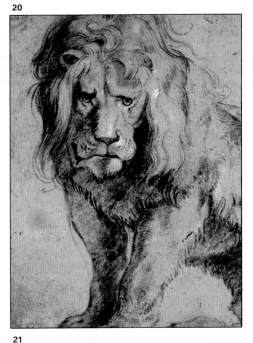

21

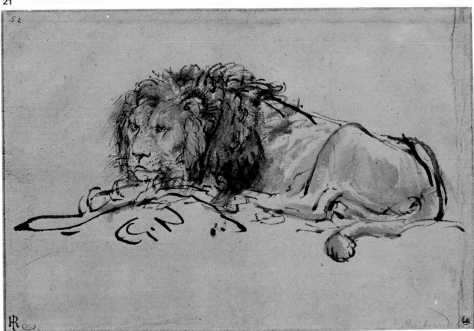

Fig. 19. Frans Snyders, *Three Greyhounds*. Herzog Anton Ulrich Museum, Braunschweig, Federal Republic of Germany. The influence of Rubens is clearly seen in this conscientious study of three animals.

Fig. 20. Peter Paul Rubens, *Lion*. Louvre, Paris (cliché de Musées Nationaux, Paris). Rubens's fondness for images expressing force and energy is fully revealed in the figure of this lion.

Fig. 21. Rembrandt Van Rijn, *Lion Resting*. Louvre, Paris (cliché de Musées Nationaux, Paris). Rembrandt was a master of drawing, particularly when employing the loose, vibrant style of this picture.

The eighteenth and nineteenth centuries

In this age, realism and romanticism were continually united and related. Animals were frequently drawn and painted in the most varied poses. The bovine family in Fig. 24 on the opposite page, painted by Sir Edwin Landseer, is an example of nature in the wild, with the head of the male standing out against the sky in a proud, protective gesture. This type of portrayal of animals abounded in England at this time. Thomas Gainsborough often painted the pets of English children, sometimes combining master and animal in one portrait and sometimes portraying the dogs alone, as in Fig. 23. Other painters, such as George Stubbs, exclusively painted animals on their own, generally horses. Delacroix sometimes took inspiration from French romantic themes. Stubbs's painting of the horse fighting the lion, shown in Fig. 22, is based on an ancient source.

22

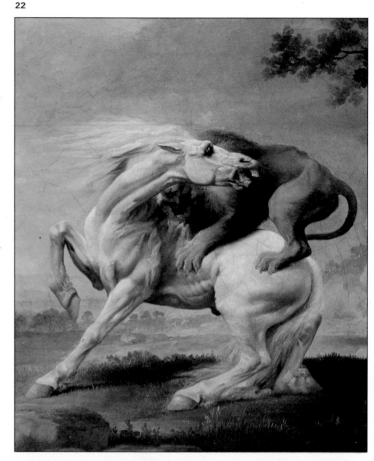

23

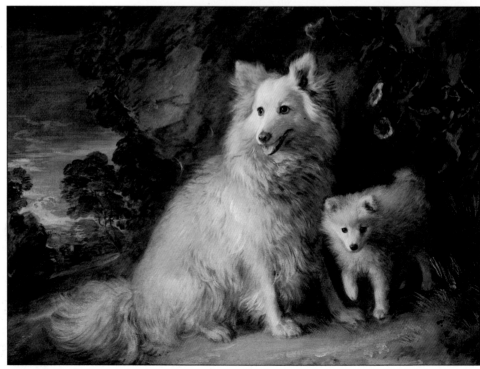

Fig. 22. George Stubbs, *Horse Attacked by a Lion* (detail). National Gallery of Victoria, Melbourne, Australia. The English Romantic painter Stubbs was a specialist in the painting of horses. In this example of his work, he adds drama through the depiction of the attack of the lion, revealing also in this painting his profound knowledge of animal anatomy.

Fig. 23. Thomas Gainsborough, *Pomeranian Dog*. Tate Gallery, London. Gainsborough was the favorite painter of the English upper classes at the end of the eighteenth century. For this reason the animals in his pictures had to possess a certain pedigree, the charm and elegance being provided by the skill of the artist.

24

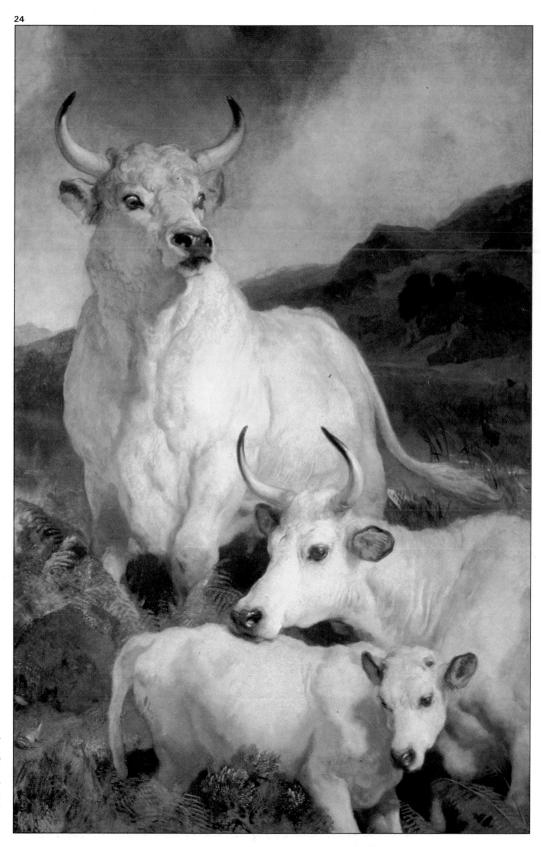

Fig. 24. Sir Edwin Landseer, *Wild Cattle at Gillingham*. Laing Art Gallery (Tyne and Wear Museums Service, London).

The nineteenth and twentieth centuries

The artistic period preceding impressionism is similar in its approach to the previous age, which combined romanticism and realism. This is the case of Marià Fortuny, who painted great battles set in African landscapes, full of both people and animals. However, the style of these paintings, with their looseness of brushstroke, approached that of impressionism.

In the mid-nineteenth century, a phenomenon occurred in painting that became known as realism. At the same time, the great illustrators and painters of the day used this new objective, naturalist attitude to incorporate social criticism into their work. Animals were introduced into these paintings and drawings to represent people, ridiculing the supposed intelligence of human society.

Side by side with this movement was the scientific function of classifying and identifying animals. Soon the impressionists took up everyday themes as their

25

subject matter once again, abandoning historic or mythological scenes and turning instead to horse races or ladies walking their dogs in the park. With their revolutionary new vision, they tried to capture the moment, the impression. The horses painted by Degas, Manet, and Toulouse-Lautrec are memorable for their movement and realism. All were masters of the art of drawing, and they depicted the horse—our companion throughout history—with great fidelity and a splendid graphic clarity.

In North America, painting portrayed events from the conquest of America up to the Industrial Revolution. Some of the works of Frederic Remington, depicting the life and culture of the Indians and their contact with nature, form an impressive incursion into purely documentary painting.

Fig. 25. Marià Fortuny, *The Battle of Tetuan* (detail). Museum of Modern Art, Barcelona. This Catalan painter shared the Romantic taste for exotic themes, and many of his works are set in Africa. *The Battle of Tetuan* is one of his most ambitious paintings.

Fig. 26 (right). Gabriel von Max, *Monkeys as Art Critics*. Alte Pinakothek, Munich. This piece provides us with a good example of the realist tendencies dominant in European art during the middle of the nineteenth century, a realism that was often combined with a sense of social criticism. In this painting, biting naturalistic observation is employed to produce the sarcastic effect of the almost-human monkeys.

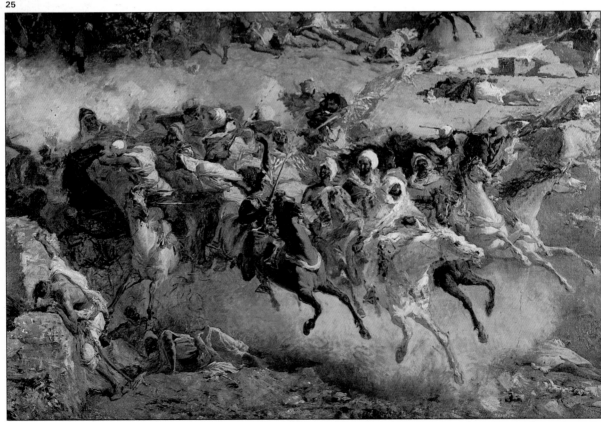

26

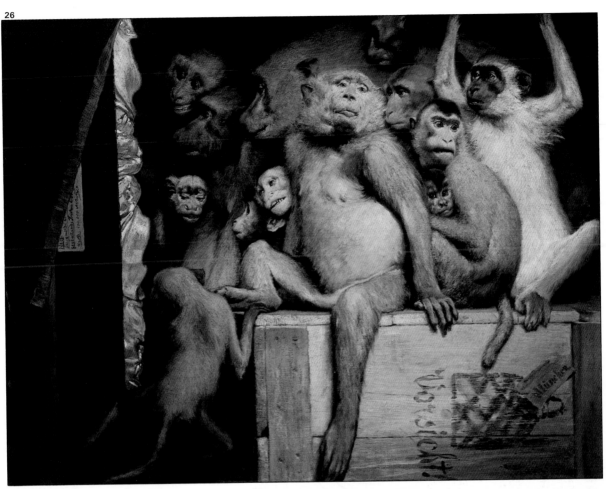

27

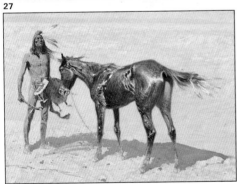

28

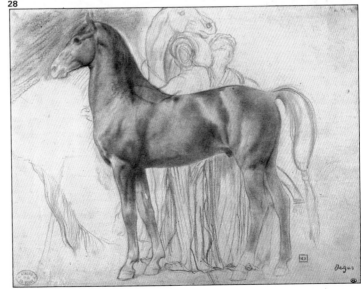

Fig. 27. Frederic Remington, *Unmounted*. Amon Carter Museum, Fort Worth, Texas. Remington painted the savage life of the immense territories of America, becoming a master of the art of painting colts, ponies, and wild horses.

Fig. 28. Edgar Degas, *Study of a Horse with Figures*. Drawings Room of the Louvre, Paris. Degas painted and drew themes from nature with consummate mastery. This horse is imbued with the sensitive realism and linear precision that characterize this great French artist.

I must insist that you will not be able to draw or paint animals from real life, with the subject in front of you, until you are able to memorize its form and physical features at the same time. This is the basic requirement for success. This skill can be nurtured and learned, just as the artist who draws the human figure has learned human anatomy and knows how to draw the figure from memory. The first step toward learning to paint animals is to study the following pages. The section on the basics of drawing animals will introduce you to the skeleton and the muscles. It will also show you how to build a complex structure from basic shapes, how to handle the play of light and shade, and how to model form with value contrast. I would like to ask you to copy some of Ballestar's drawings, for if you do, you will be on the way to acquiring the fabulous skill of those who, like Ballestar, have mastered the art of drawing and painting animals.

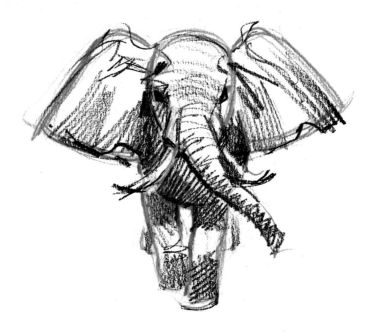

THE BASICS OF DRAWING ANIMALS

Bone and muscle anatomy, basic
structure derived from basic shapes,
light and shade, value and contrast.

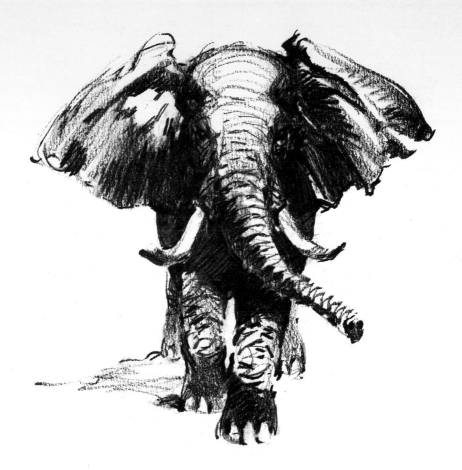

The skull

Generally speaking, the skulls of all land mammals have very similar characteristics, being basically made up of a number of flat, irregularly shaped bones that are fused together without joints to permit movement, except in the jaw.

The skull has an unusual number of prominences and holes because of the multiple functions centered in it. These include chewing, breathing and, above all, those of the organs of the five senses, which are situated in the skull. These functions require specific features. For instance, in a ruminant (such as a deer or giraffe), the incisors and canine teeth are clearly separated, and this determines the shape of the jaw. Of course, the shape of the skull has a direct influence on the external appearance of the head of the animal. Remember too that the skull also contains various muscles and structures made of cartilage—the snout or muzzle, the ears, the mouth—which also make their mark on the shape of the head, giving the animal its characteristic appearance and shape.

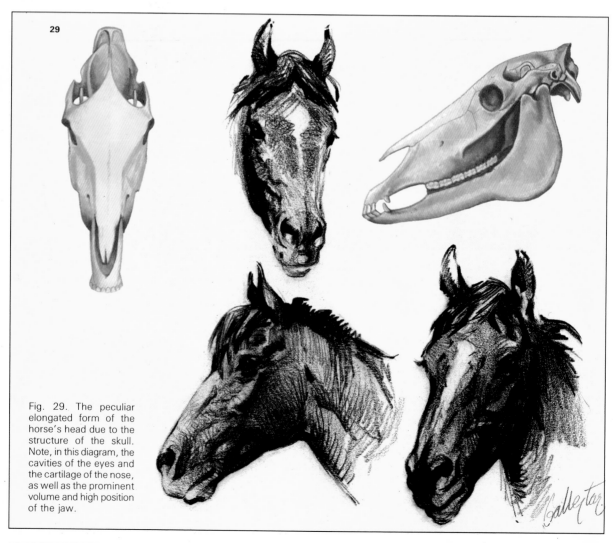

29

Fig. 29. The peculiar elongated form of the horse's head due to the structure of the skull. Note, in this diagram, the cavities of the eyes and the cartilage of the nose, as well as the prominent volume and high position of the jaw.

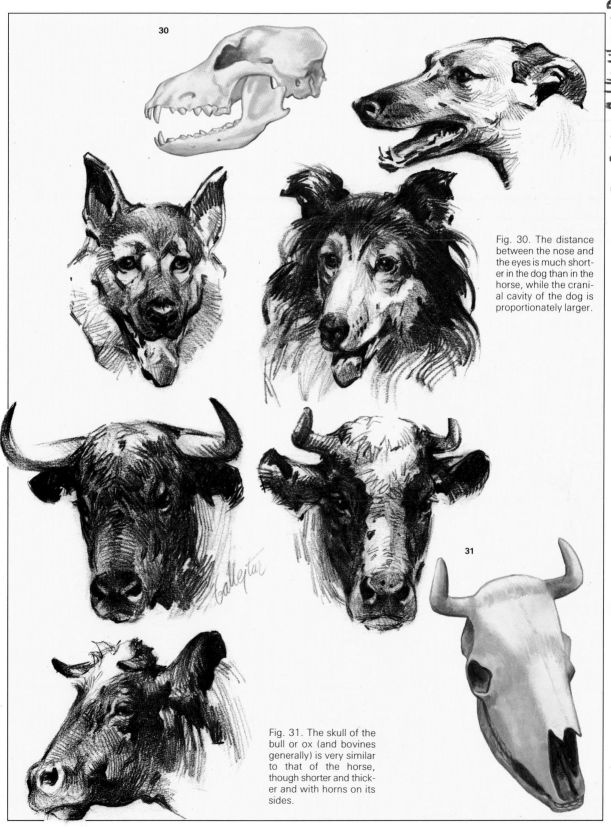

Fig. 30. The distance between the nose and the eyes is much shorter in the dog than in the horse, while the cranial cavity of the dog is proportionately larger.

Fig. 31. The skull of the bull or ox (and bovines generally) is very similar to that of the horse, though shorter and thicker and with horns on its sides.

The feline skull

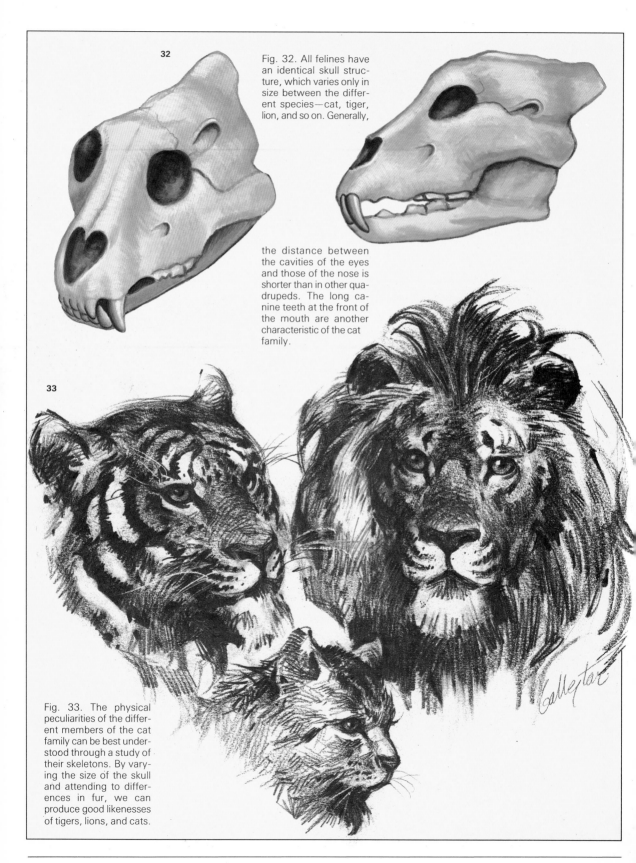

Fig. 32. All felines have an identical skull structure, which varies only in size between the different species—cat, tiger, lion, and so on. Generally, the distance between the cavities of the eyes and those of the nose is shorter than in other quadrupeds. The long canine teeth at the front of the mouth are another characteristic of the cat family.

Fig. 33. The physical peculiarities of the different members of the cat family can be best understood through a study of their skeletons. By varying the size of the skull and attending to differences in fur, we can produce good likenesses of tigers, lions, and cats.

Details of the head

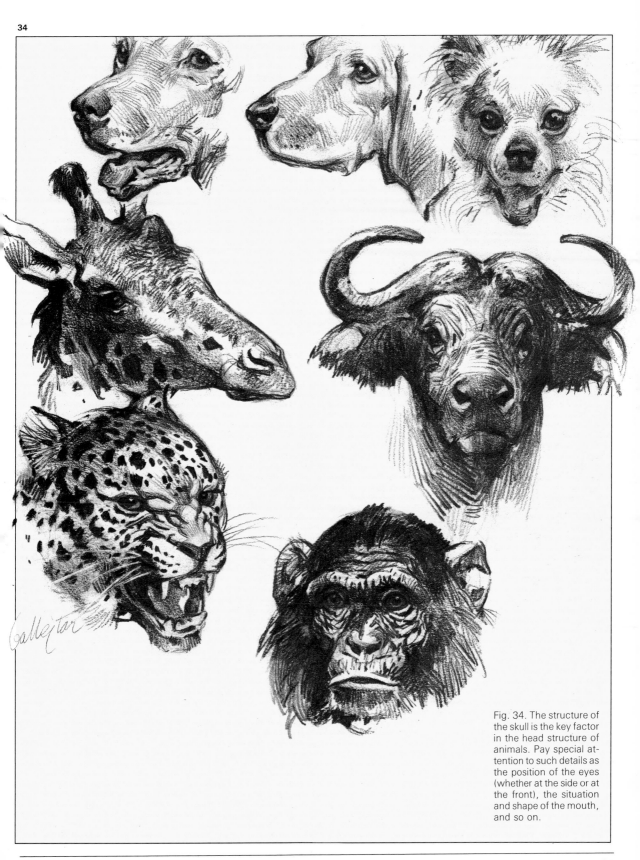

Fig. 34. The structure of the skull is the key factor in the head structure of animals. Pay special attention to such details as the position of the eyes (whether at the side or at the front), the situation and shape of the mouth, and so on.

A comparison of the anatomies of man and the horse

To make it easier to understand the skeletal and muscular anatomy of animals, we will compare the anatomy of man with that of the horse. I have chosen the anatomy of the horse as my model of animal anatomy because its characteristics can be extended to include those of most land mammals. Once you have mastered the peculiarities of this creature, it will not be difficult to capture the anatomy of any other four-legged animal.

Fig. 35 shows the skeletons of man and the horse. Note that the skull of the horse is much longer than that of the man, and that its cranial cavity is much smaller. The joints of the cervical vertebrae, seven both in man and in the horse, are to be found in the neck. Note, again, that those of the horse are bigger and more powerful. The front legs of the horse, corresponding to the arms of a man, reveal a distribution of joints similar in number to those of man, but different

35

in proportion. The horse's "upper arm" is proportionately smaller, hardly protruding from the body. The most visible joint is the one corresponding to the wrist of a man, and which is continued by a long, straight hand ending in the hoof, formed by four fingers welded together. Similarly, the rear limbs have as their most visible joint the one corresponding to the ankle of a man, the joint corresponding to the knee being partially hidden by the haunches.

In Fig. 36, the reader can compare the muscular anatomies of the horse and man. The muscles of the horse are predominantly centered around the neck and the haunches and much less so in the trunk, since the horse does not need the support function of these muscles (fundamental to maintain the characteristic upright posture of man).

Fig. 35. Besides differences in the size of the skeletons of a horse and a man, another revealing difference is the comparatively larger thorax of the horse and its more elongated skull. Regarding the limbs, the horse has a larger "forearm" and phalanges, and the joints corresponding to the elbow and knees are placed higher up on the legs.

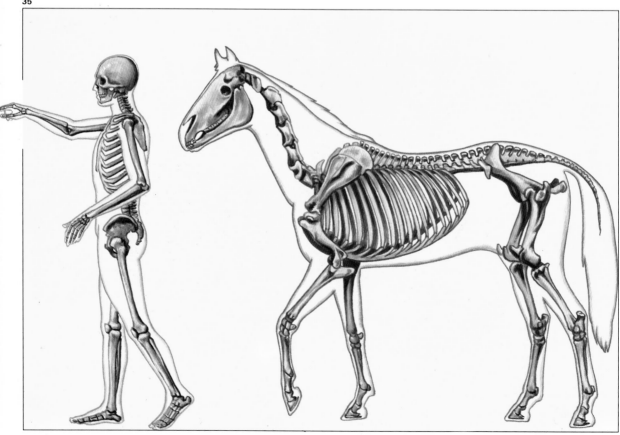

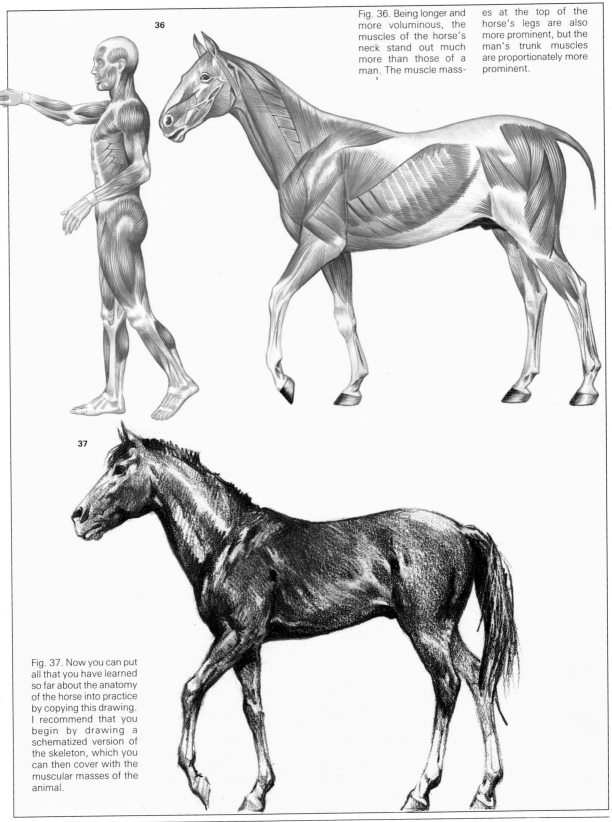

Fig. 36. Being longer and more voluminous, the muscles of the horse's neck stand out much more than those of a man. The muscle mass- es at the top of the horse's legs are also more prominent, but the man's trunk muscles are proportionately more prominent.

Fig. 37. Now you can put all that you have learned so far about the anatomy of the horse into practice by copying this drawing. I recommend that you begin by drawing a schematized version of the skeleton, which you can then cover with the muscular masses of the animal.

Skeletal and muscular anatomy

38

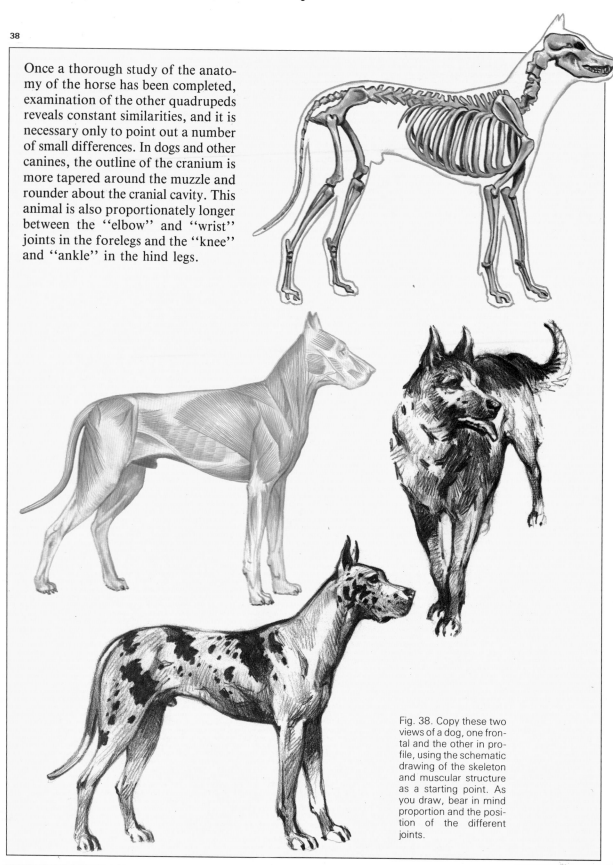

Once a thorough study of the anatomy of the horse has been completed, examination of the other quadrupeds reveals constant similarities, and it is necessary only to point out a number of small differences. In dogs and other canines, the outline of the cranium is more tapered around the muzzle and rounder about the cranial cavity. This animal is also proportionately longer between the "elbow" and "wrist" joints in the forelegs and the "knee" and "ankle" in the hind legs.

Fig. 38. Copy these two views of a dog, one frontal and the other in profile, using the schematic drawing of the skeleton and muscular structure as a starting point. As you draw, bear in mind proportion and the position of the different joints.

39

The members of the feline family also have a similar skeletal and muscular anatomy. The differences between a tiger and a leopard, or a cat and a lion, regard only size and fur. Under the skin, they all have an identical distribution of bones and muscles. It is useful to note that the head differs from that of the dog in being flatter, and that the distance between the muzzle and the eyes is shorter. The feline also has a somewhat less tapered trunk than the dog.

Fig. 39. Now, as you did with the dog, use these two views of a lion for more drawing practice, paying attention to the peculiarities of anatomy. I suggest that you begin by drawing the anatomy of the animal, as if it were any member of the feline family, and that you leave the mane until last.

Comparative anatomy

Just as we can usefully compare the skeletal and muscular anatomy of man and the rest of the higher mammals, so we can also establish similarities and differences in how the skeletons are arranged. The animals known as plantigrades, which include the bear, the monkey, and the elephant, walk on the soles of their feet just like man. But most other mammals walk on the tips of their toes, like a ballerina. In Fig. 40, you can compare the physical structure of a deer with that of a man in crouching, almost squatting, position.

The similarity of the man's legs and the hind legs of the deer is clear; only the distance between the joints is different. In the man the femur, or thigh bone, is the longest in the body, but in the deer the corresponding bone is much shorter, so that the "hip" and "knee" are close together. It is also interesting to note that the distances between the joints in the man's hand and foot are much shorter than in the deer.

Fig. 40. Although the distances between joints in the skeleton of a man and a deer are different, the number of joints is nearly identical. This can be clearly seen by comparing the animal with the human figure in crouching position.

Fig. 41. Remembering that the joints of the limbs are essentially the same for all quadrupeds, draw these back legs of a horse, a tiger, a deer, and a dog.

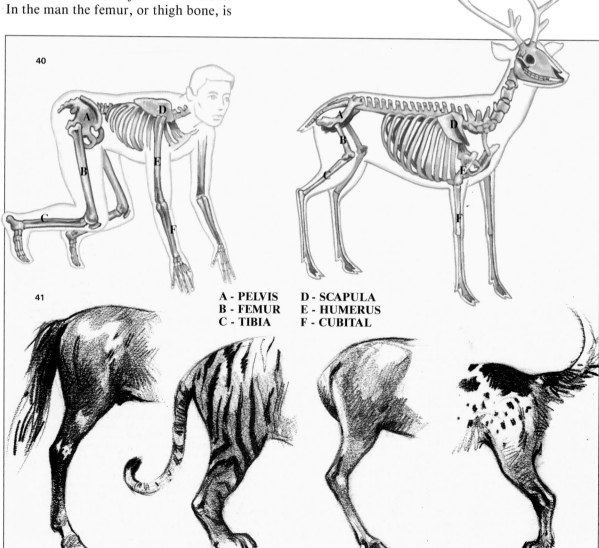

40

41

A - PELVIS D - SCAPULA
B - FEMUR E - HUMERUS
C - TIBIA F - CUBITAL

Birds have a basic structure similar to that of the animals we have already studied. Their bone structure is formed by the head and the spine, to which the thorax and the four limbs are attached. The front limbs (equivalent to the arms) have developed into wings that remain parallel to the number and kind of bones in other animals. The shape of the back limbs is similar to that of the quadrupeds. But instead of fingers birds have talons. The jawbone lacks teeth and is clothed by a horny cover that forms the beak. Apart from the short distance between front and back limbs and the great length of the front ones, the structure of birds is really quite similar to that of quadrupeds.

Fish have a structure that consists mainly of the cranium (irregular and weaker than the terrestrial animals') and the spine. The spine is connected to bones that form a sort of thorax and extend to the fins.

Fig. 42. While the skeleton of the bird is similar in many ways to that of quadrupeds, a fish's skeleton contains only the head, the spine, and various rows of small bones.

Fig. 43. The flight of a bird can be compared with nothing in the quadruped's world except the sideways up-and-down movement of a man's arms.

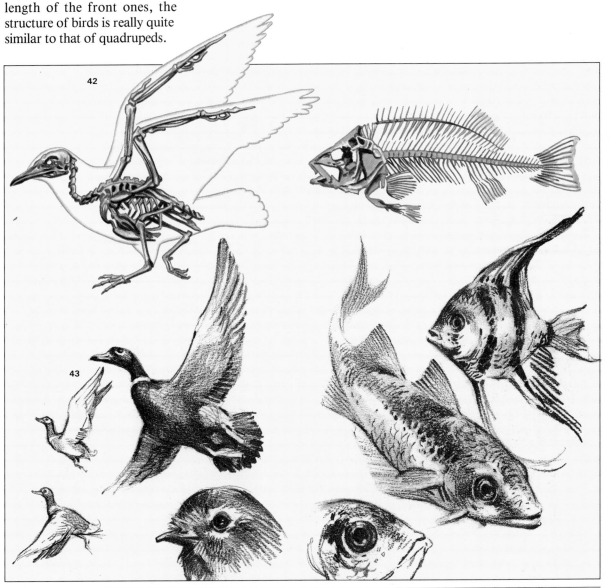

Cézanne's formula

44

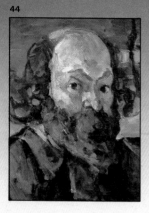

Fig. 44. Paul Cézanne, *Self-Portrait*. Orsay Museum, Paris.

Figs. 45 and 46. The cube, the cylinder, the sphere, and the cone are the basic geometrical forms whose sections or shapes can be combined to represent any natural form, whether still or in motion.

45

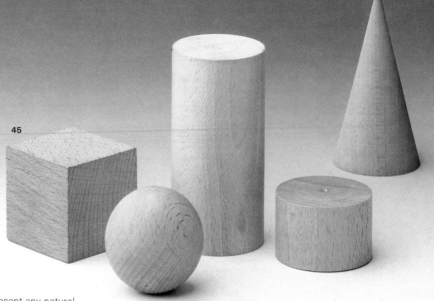

46

In April 1904, the Provençal painter Paul Cézanne wrote the following to his friend and fellow artist Emile Bernard: "In nature, everything is modeled on three basic forms: the cube, the cylinder, and the sphere. The artist has to learn to draw these basic forms and then he can draw anything he wants."

Cézanne was obsessed by the idea of basing his work on the regularity of geometry, of reducing the diversity of natural forms to the uniform clarity of simple geometric figures. Cézanne's insight quoted above can be of great use to the artist who wishes to tackle the complexity of nature.

You will remember that, when talking of drawing from real life, I emphasized observation of nature as a preliminary step before drawing, and that I strongly stressed the need to memorize the essence of a form in movement. Well, Cézanne's use of regular forms can be of immense help in achieving this objective. In the exercises that follow, you will see that a representation of the form of absolutely any animal can be reduced to a combination of these basic shapes.

A horse seen in near-profile

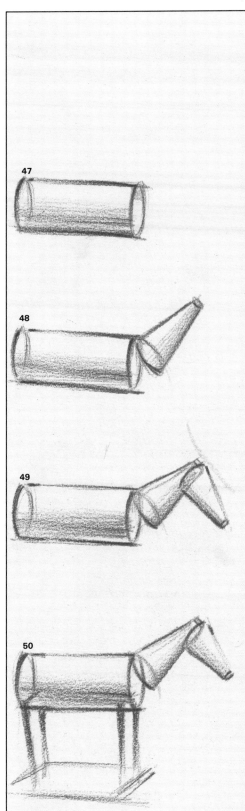

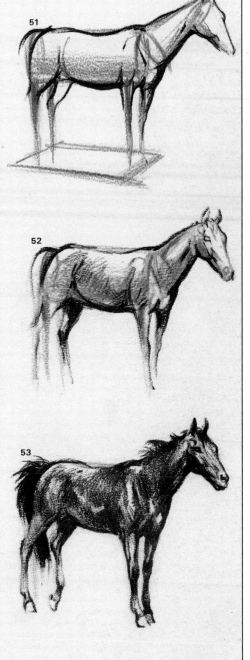

Fig. 47. This first exercise consists of drawing the form of a horse using these simple shapes, building up the structure through the juxtaposition of cylinders, spheres, and cones. Here you can see how the trunk is represented by a horizontally placed cylinder. Make sure the length of the cylinder is correct in relation to its width, so that it really corresponds to the proportions of the animal.

Fig. 48. The neck can be represented by placing a slightly truncated cone at an angle to the cylinder, which gives us the body.

Fig. 49. Another cone, placed at a right angle to the end of the previous one, gives us a schematic representation of the head of the horse.

Fig. 50. The legs are formed by vertical lines at the ends of the cylinder. To calculate the length of the legs, draw a rectangle parallel to the cylinder at the same angle in perspective.

Fig. 51. Once the proportions of the geometric structure have been satisfactorily obtained, we can start to draw the outline of the animal, the form of the haunches, the volume of the chest, and the point where the neck joins the head. At this point, it is very important to keep our knowledge of animal anatomy firmly in mind.

Fig. 52. Now we draw in the nose, the ears, and the tail. By lightly shading with a 4B or 6B pencil, we can suggest the volumes of the body and neck. Note that the legs are gradually beginning to take shape.

Fig. 53. Here is finished drawing, with the outlines now strengthened, the volumes filled out, and the mane and tail shaded in.

A horse in three-quarter position

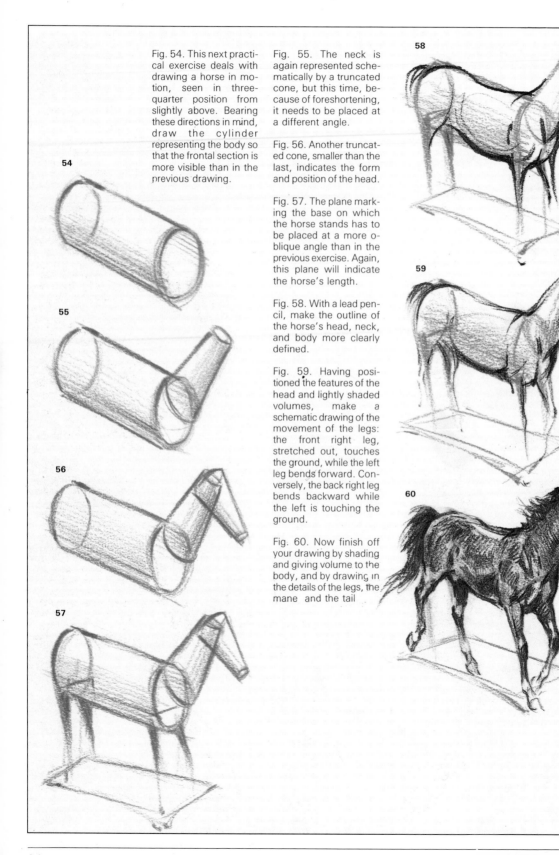

Fig. 54. This next practical exercise deals with drawing a horse in motion, seen in three-quarter position from slightly above. Bearing these directions in mind, draw the cylinder representing the body so that the frontal section is more visible than in the previous drawing.

Fig. 55. The neck is again represented schematically by a truncated cone, but this time, because of foreshortening, it needs to be placed at a different angle.

Fig. 56. Another truncated cone, smaller than the last, indicates the form and position of the head.

Fig. 57. The plane marking the base on which the horse stands has to be placed at a more oblique angle than in the previous exercise. Again, this plane will indicate the horse's length.

Fig. 58. With a lead pencil, make the outline of the horse's head, neck, and body more clearly defined.

Fig. 59. Having positioned the features of the head and lightly shaded volumes, make a schematic drawing of the movement of the legs: the front right leg, stretched out, touches the ground, while the left leg bends forward. Conversely, the back right leg bends backward while the left is touching the ground.

Fig. 60. Now finish off your drawing by shading and giving volume to the body, and by drawing in the details of the legs, the mane and the tail

The legs of a horse

The legs of a horse have a very definite structure, both in terms of form and in terms of the pattern of joints that make it up. It is a good idea to make a thorough study of them, building them up schematically with the simple volumes we have been using. Remember, too, that this basic structure can be applied to almost all quadrupeds, with some modifications.

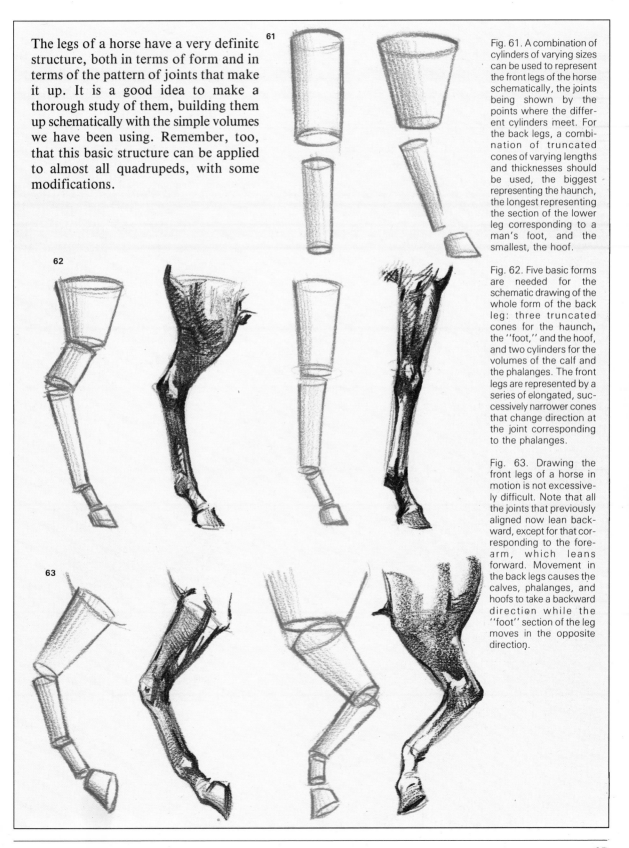

Fig. 61. A combination of cylinders of varying sizes can be used to represent the front legs of the horse schematically, the joints being shown by the points where the different cylinders meet. For the back legs, a combination of truncated cones of varying lengths and thicknesses should be used, the biggest representing the haunch, the longest representing the section of the lower leg corresponding to a man's foot, and the smallest, the hoof.

Fig. 62. Five basic forms are needed for the schematic drawing of the whole form of the back leg: three truncated cones for the haunch, the "foot," and the hoof, and two cylinders for the volumes of the calf and the phalanges. The front legs are represented by a series of elongated, successively narrower cones that change direction at the joint corresponding to the phalanges.

Fig. 63. Drawing the front legs of a horse in motion is not excessively difficult. Note that all the joints that previously aligned now lean backward, except for that corresponding to the forearm, which leans forward. Movement in the back legs causes the calves, phalanges, and hoofs to take a backward direction while the "foot" section of the leg moves in the opposite direction.

The horse in various positions

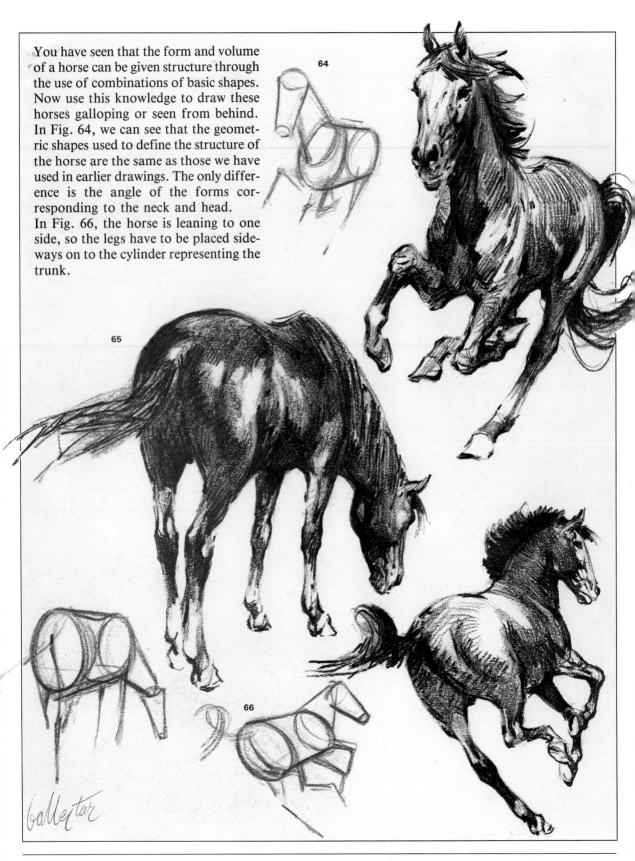

You have seen that the form and volume of a horse can be given structure through the use of combinations of basic shapes. Now use this knowledge to draw these horses galloping or seen from behind. In Fig. 64, we can see that the geometric shapes used to define the structure of the horse are the same as those we have used in earlier drawings. The only difference is the angle of the forms corresponding to the neck and head.

In Fig. 66, the horse is leaning to one side, so the legs have to be placed sideways on to the cylinder representing the trunk.

The dog and the cat

The formula for constructing the running dog in Fig. 67 is basically the same as for the horse, with variations in the neck, which is hidden behind the head in this case.

The structure of the cat is generally made up of a combination of circles, elliptical shapes, and other rounded forms. Copy Fig. 68, paying special attention to the cylinder forming the trunk, with a circle at the top for the head and oval shapes for the hind legs.

The trunk of the cat lying down in Fig. 69 is also formed by a cylinder, this time with an oval section, and the head, again, is formed by a circle.

Various domestic animals

The structure of the goose (Fig. 70) is simple to make: an oval for the trunk, with a long, curved cone for the neck, joined to another smaller one for the head. The wings are easily drawn by two curved shapes starting out from the sides of the trunk.

The rooster presents few problems, too: again, an oval for the trunk, a triangle for the tail, another smaller triangle for the neck, and a small cone for the head (Fig. 71).

The structure of the rabbit can be schematized with the forms we have already been using. The ears can be represented by drawn-out lunes, as in Figs. 72 and 73.

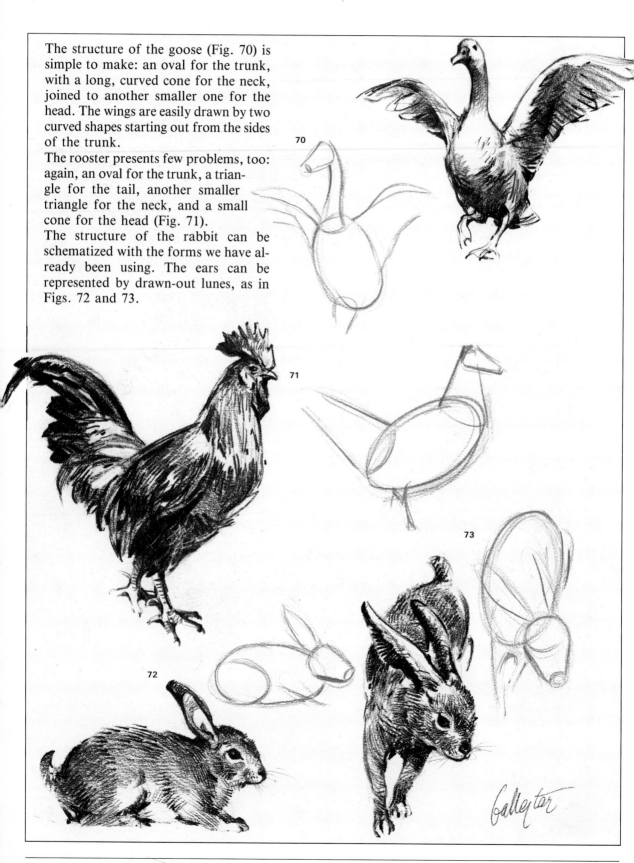

70

71

73

72

Various wild animals

The elephant is formed by the arrangement of a series of ovals for the head, body, and ears; an elongated, curved cylinder shape for the trunk, and more cylinders for the legs (Fig. 74).

The basic structure of the giraffe (Fig. 75) is the same as that of the horse, except that all the shapes making up this animal have to be elongated.

The buffalo is constructed with a truncated cone, an oval shape for the head, and a sphere to represent the prominent section of the back (Fig. 76).

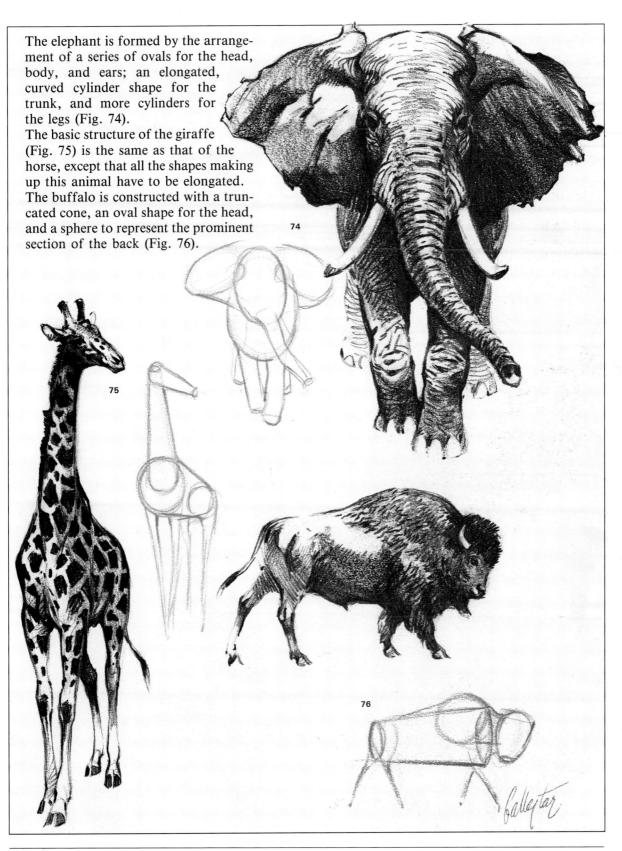

74

75

76

Three more wild animals

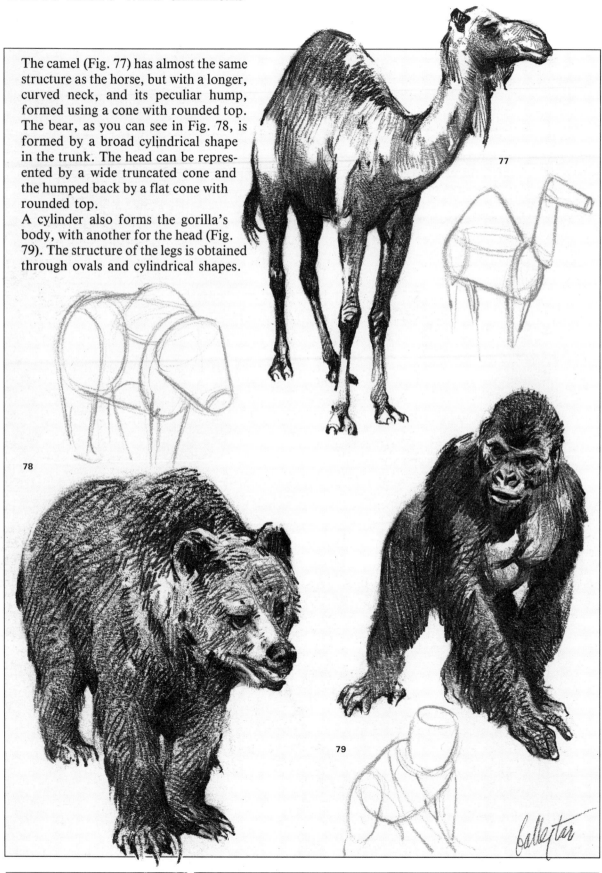

The camel (Fig. 77) has almost the same structure as the horse, but with a longer, curved neck, and its peculiar hump, formed using a cone with rounded top. The bear, as you can see in Fig. 78, is formed by a broad cylindrical shape in the trunk. The head can be represented by a wide truncated cone and the humped back by a flat cone with rounded top.

A cylinder also forms the gorilla's body, with another for the head (Fig. 79). The structure of the legs is obtained through ovals and cylindrical shapes.

77

78

79

Wild birds

The trunk of the eagle (Fig. 80) is formed by an oval shape, as in all birds. The tail can be made with a sharply pointed triangle, with smaller triangular shapes forming the neck and head.

The ostrich (Fig. 81), besides the oval for the body, has an elongated, flexible tube shape for a neck. Its head is formed by a small cone at the end of the tube.

The vulture has an oval for the body and a tube shape for the neck, though not as long. The shape of the tail is a trapezoid and the wings are parallel curves going across the body (Fig. 82).

The use of light and shade in drawing animals

Whatever your subject—whether you are painting a landscape, a human figure, or an animal—you always have to take into account the effects of light and shade, and decide the most suitable quality and direction of light for you picture. Let us now speak of quality and direction of light as applied to drawing and painting animals.

There are two basic qualities of light:

(a) *Diffused light*: the light of a cloudy day or the filtered light that comes through a skylight or a window placed high up in a wall. This is a soft light with hardly any contrast, such as when you draw or paint outdoors and the sun is covered by clouds.

(b) *Direct light*: sunlight on a clear day or the light of an electric lamp. This kind of light gives maximum contrast and occurs when you draw animals outdoors in bright sun or draw a domestic animal in the studio with strong electric lighting.

There are three basic light directions:

(a) *Frontal lighting* (Fig. 83), in which there is practically no play of light and shade. This is the least documentary and the most colorist light direction. We can take a moment to expand on this point:

There are two styles, two ways of painting. One is the valuist manner, the other the colorist manner. Valuist artists paint with light and shade, while colorists paint with plain color, without shade. The lion by Rubens and the greyhounds by Snyders reproduced on page 17 are examples of valuist painting, and the Egyptian ducks and the Cretan dolphins on page 11 are fine demonstrations of colorist art. Curiously, the painting style of the anonymous authors of these ducks and dolphins was emulated 3,000 years later, at the beginning of this century, by fauvists Matisse, Derain, and Vlaminck. Ballestar's tiger on this page is an example of frontal lighting and colorism. The side of the animal facing us is brightly lit, so that we see all its colors vividly, with few noticeable shadows.

(b) *Lateral lighting* and *lateral-frontal lighting* (Fig. 84). This is the ideal lighting for documentary art, since the exaggerated play of light and shade it produces transmits the form of the model most perfectly. The hippopotamus painted by Ballestar demonstrates this exactly. This type of lighting is much used in valuist painting.

Fig. 83. This tiger is painted in the colorist manner—that is, the shadows of the picture take nothing away from the strength of the intense, vibrant color characterizing the whole figure. This chromatic force is the result of frontal lighting.

83

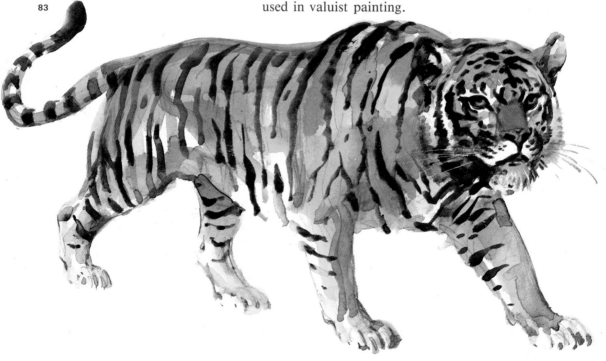

(c) *Backlighting* (Fig. 85). This is the most suitable lighting to express love, softness, and warmth. It is distinguished by the halo of light around the animal, the result of the light emanating from behind the subject.

To sum up, frontal lighting works best for modern-style colorism. Lateral or frontal-lateral lighting is ideal for documentary art whose purpose is to explain and inform. Backlighting is expressive, creative, and atmospheric.

You can choose among these directions of light depending on what you want to express.

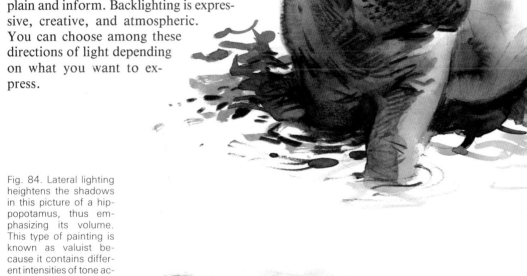

84

Fig. 84. Lateral lighting heightens the shadows in this picture of a hippopotamus, thus emphasizing its volume. This type of painting is known as valuist because it contains different intensities of tone according to whether the parts of the figure are illuminated or in shade.

85

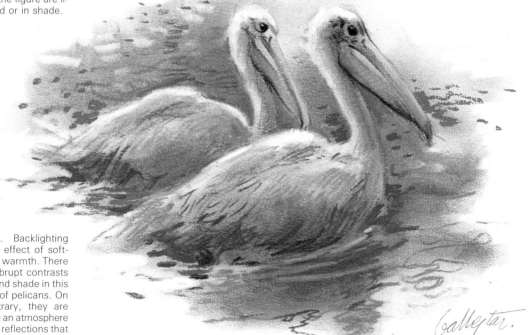

Fig. 85. Backlighting gives an effect of softness and warmth. There are no abrupt contrasts of light and shade in this painting of pelicans. On the contrary, they are bathed in an atmosphere of gentle reflections that suggest a calm and peaceful time of day.

Using value to model form

Values are tones. The volume of an object is expressed through modeling—that is, the gradation of values or tones. When Ballestar draws a dog, a cat, a horse, or a lion, he does not just draw lines or outlines. From the first pen-strokes, he draws and constructs with tones, with grays and gradations of color that express form. This is because shapes are not made up of outlines, but of light and dark areas, or values and tones. It is important to remember this.

Modeling form takes much practice, for values are tones of infinite variations of intensity, going from a gray so light as to be almost white to the purest black. The artist must copy these tones, constantly comparing one tone with all the others, to get the value or tone required.

Fig. 86. Ballestar began to draw this deer by valuing its volumes—that is, gradually varying the intensity of light and shade so that the precision of the outline blends with the shaded areas. The artist worked on both of these aspects, outline and shade, simultaneously until the picture was finished.

86

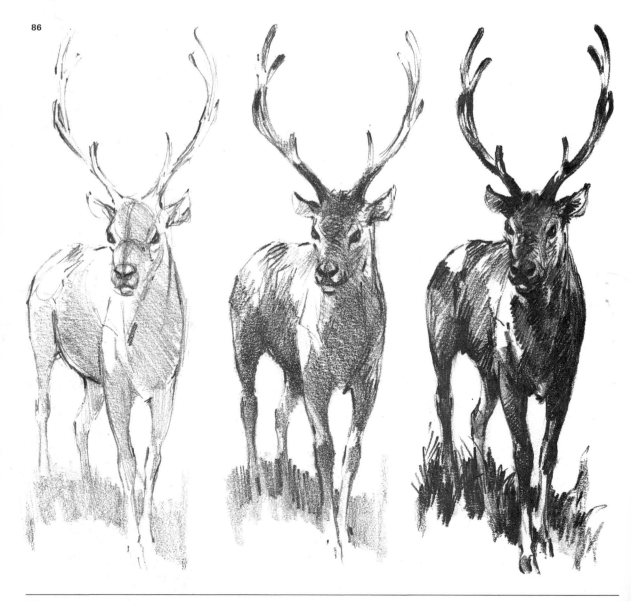

Contrast

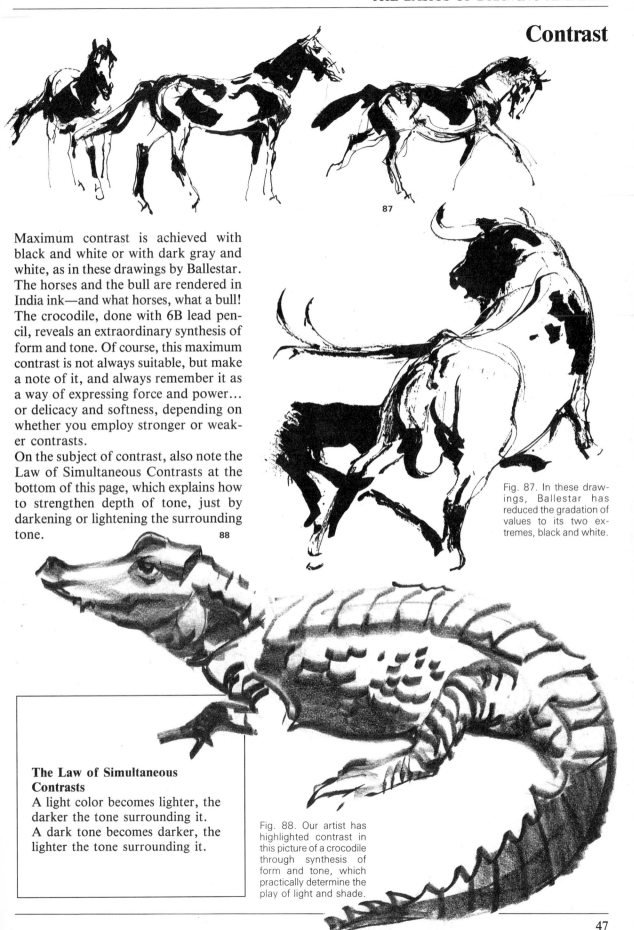

87

Maximum contrast is achieved with black and white or with dark gray and white, as in these drawings by Ballestar. The horses and the bull are rendered in India ink—and what horses, what a bull! The crocodile, done with 6B lead pencil, reveals an extraordinary synthesis of form and tone. Of course, this maximum contrast is not always suitable, but make a note of it, and always remember it as a way of expressing force and power... or delicacy and softness, depending on whether you employ stronger or weaker contrasts.

On the subject of contrast, also note the Law of Simultaneous Contrasts at the bottom of this page, which explains how to strengthen depth of tone, just by darkening or lightening the surrounding tone.

88

Fig. 87. In these drawings, Ballestar has reduced the gradation of values to its two extremes, black and white.

The Law of Simultaneous Contrasts

A light color becomes lighter, the darker the tone surrounding it.
A dark tone becomes darker, the lighter the tone surrounding it.

Fig. 88. Our artist has highlighted contrast in this picture of a crocodile through synthesis of form and tone, which practically determine the play of light and shade.

First we will look at the materials: the drawing pencil, with its thick lead, or the softer mechanical pencil. We'll discuss techniques of holding the pencil with its wedge-shaped tip to alternate broad shading with linear drawing. Structure, basic form, and geometry give us a first approach to the form of the animal. After this, we calculate, at first mentally and then on paper, the animal's dimensions and proportions. All this goes into producing a definitive sketch. And as a complement to this interesting subject matter, you will see several sketches of animals posing, seen as they develop step by step, so that you can see how Ballestar draws them. This is the eminently practical content of this chapter.

QUICK SKETCHES
OF
ANIMALS POSING

The sketch, the structure, dimensions, and proportions, and how to sketch animals posing.

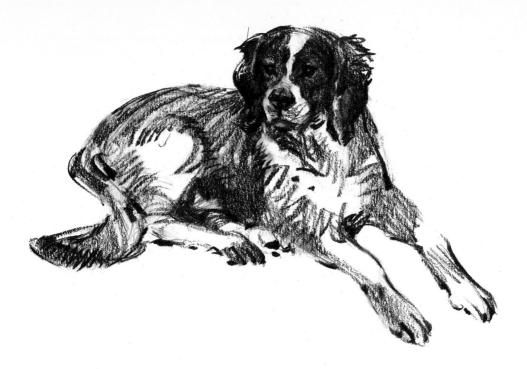

Techniques of sketching with lead pencil

With his left hand, always with his left hand, Ballestar draws with a Koh-I-Noor pencil whose lead is 3/16 inch (5 mm) in diameter, and with a special mechanical pencil, also made by Koh-I-Noor. His tools are completed by a Staedtler plastic eraser and a 100-sheet block of 12 × 16 inch (35 × 43 cm) Vic de Grumbacher paper.

"Always?" I ask.

"No, when the sketch is going to be published I use Schoeller Turm paper."

In Figs. 90 and 92 on this page, you can see Ballestar's sketching technique. First he sharpens his pencil lead to a chisel-shaped wedge so that he can draw lines of any thickness (Fig. 89) and grays or broad areas of tone (Fig. 91).

"And see how, when I want to reinforce or darken the shading, I slowly turn the pencil in my hand, and the stroke I make becomes automatically more intense, darker," he explains.

You can see the results of Ballestar's technique in the series of sketches on the opposite page. Note that, when Ballestar makes sketches like these, he holds the pencil in different ways, sometimes with the "stick" of the pencil inside his hand, as you can see in Fig. 93, and sometimes holding it in the conventional way, as one normally writes.

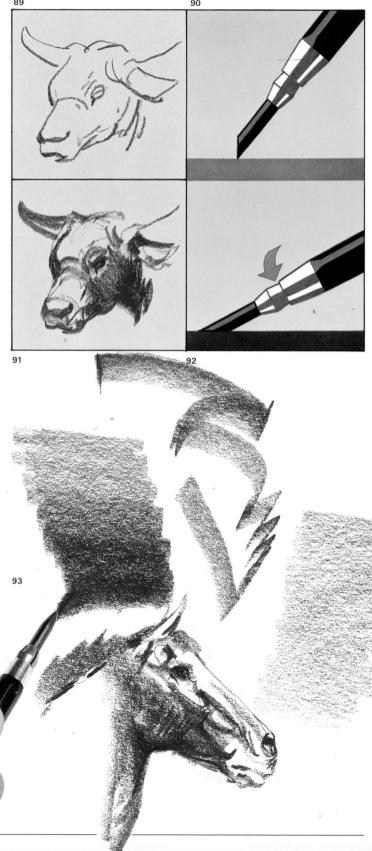

Fig. 93. Holding the pencil with the stick inside the palm of his hand, Ballestar rubs it sideways across the paper and shows us how to achieve uniform shading of various areas of a drawing.

This shading can be intensified by turning the pencil around as you draw, so that the sharp edge of the chisel point produces a darker shading.

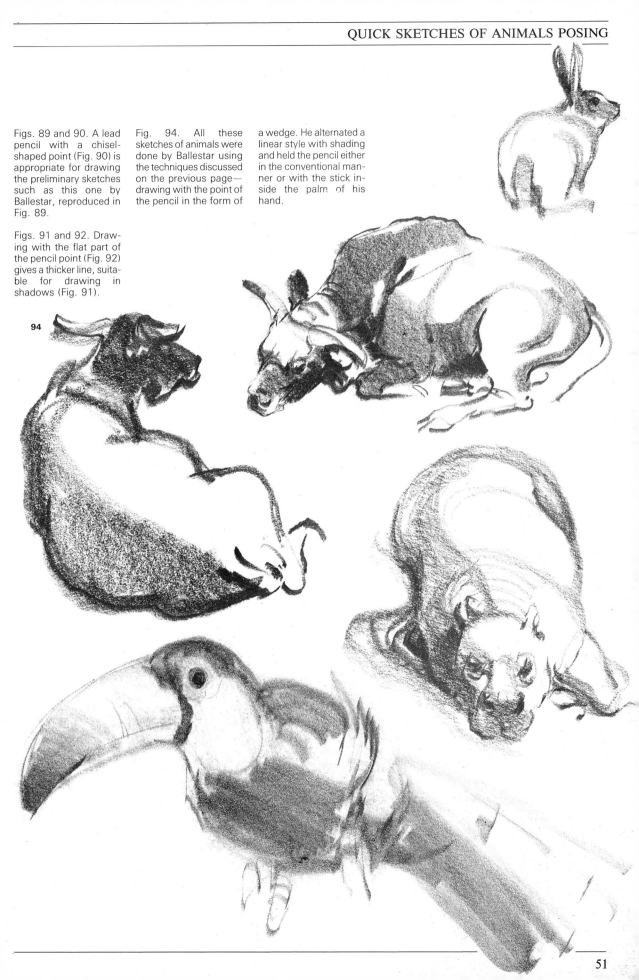

Figs. 89 and 90. A lead pencil with a chisel-shaped point (Fig. 90) is appropriate for drawing the preliminary sketches such as this one by Ballestar, reproduced in Fig. 89.

Figs. 91 and 92. Drawing with the flat part of the pencil point (Fig. 92) gives a thicker line, suitable for drawing in shadows (Fig. 91).

Fig. 94. All these sketches of animals were done by Ballestar using the techniques discussed on the previous page—drawing with the point of the pencil in the form of a wedge. He alternated a linear style with shading and held the pencil either in the conventional manner or with the stick inside the palm of his hand.

94

First series of sketches

We are at the home of Ballestar's daughter Blanca, with her dog Escarlata. This is a familiar place to the dog, though she seems a little restless because of the presence of strangers. (The photographer is taking photos with his flash camera and I am dictating notes into a cassette recorder.)
But Ballestar is already sketching Escarlata. With absolute concentration, he spends a fair time looking at the dog—two, three, four minutes. He places himself so that he only has to look up from his paper, to see the animal he is going to draw. Five, six minutes ... then, suddenly, he begins to draw, with a slow, sure hand, tracing the lead over the paper, alternating his manner of holding the pencil between the conventional grip and cupping it in his hand. Escarlata starts moving, and Blanca speaks to her: "Stay, girl, stay." And the dog sits, then lies down, moves her head, looks at Ballestar, who has not remained still either. One sketch, two, three... in less than a quarter of an hour, he completes a dozen sketches. How does he do it? How does he structure and draw with such apparent ease?

95

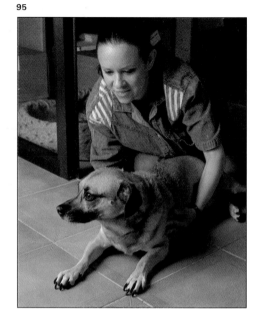

Fig. 95. In this photograph we can see Ballestar's daughter Blanca with her dog Escarlata, a magnificent subject for the real-life sketches that Ballestar has made for us.

96

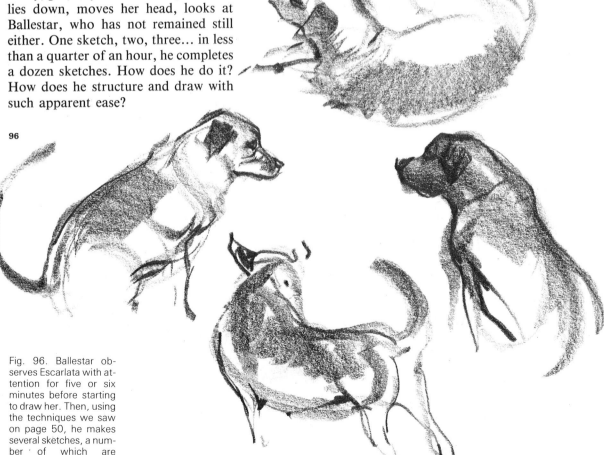

Fig. 96. Ballestar observes Escarlata with attention for five or six minutes before starting to draw her. Then, using the techniques we saw on page 50, he makes several sketches, a number of which are reproduced here.

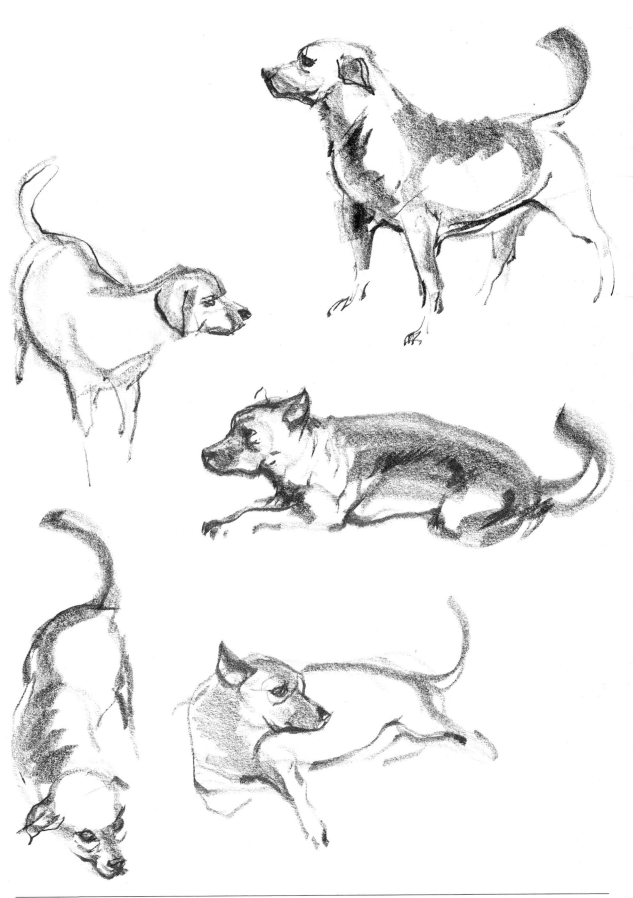

Structuring the basic form

For this next exercise, I will assume that you have access to a dog that you can draw from real life. What you have to do to follow the same process as Ballestar, as outlined below.

First, draw the dog, first in profile, sitting down, without foreshortening, in the typical pose which dogs and cats adopt when resting.

Begin by carefully studying the animal, trying to work out general and particular forms in your mind (Figs. 100 and 97). Just looking, not drawing yet, relate the overall shape to a basic form, a triangle in this case (Fig. 101). Adjust this initial form by cutting off the left-hand apex of the triangle and putting in the schematized shape of the head (Figs. 102 and 98). You should also study the negative shapes formed by the background, as if you were seeing the dog as a negative photograph (Fig. 103): this way, you can see, for instance, the shape marked with the letter A, between the animal's legs, and the angle formed by the outline of the chin and neck (B), or the angle of the profile or line running from the neck to the bottom of the legs (C). Memorize this basic outline or profile (Figs. 104 and 99), noting the form of the nose, of the eye, the ear, the chest, the legs, and so on. Finally, try to visualize the tones and values of your picture: half-close your eyes to see the play of light and shade, contrast, and color more clearly.

You should spend as little time as possible in observing, imagining, and working out all these aspects of your picture. Once Ballestar has completed such a mental study, he begins drawing, almost always with outline of the top of the head, then the shoulder, the back, the nose, and so on. Of course, I wrote all this according to the process followed by our guest artist, but the reader can simplify matters by first drawing the initial basic form (Fig. 101), then adjusting this more to the exact shape of the model (Fig. 102), and so on.

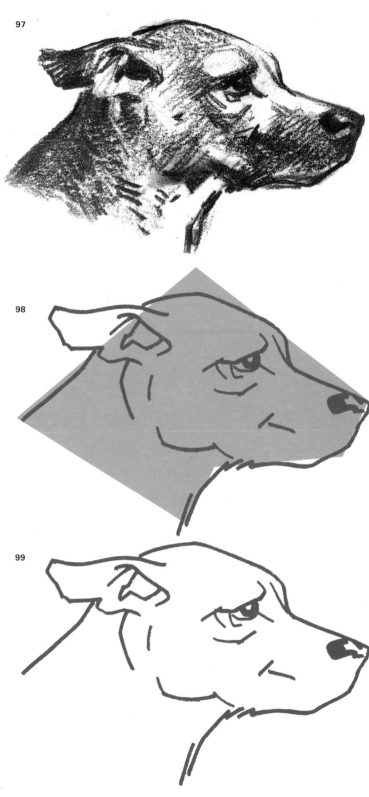

97

98

99

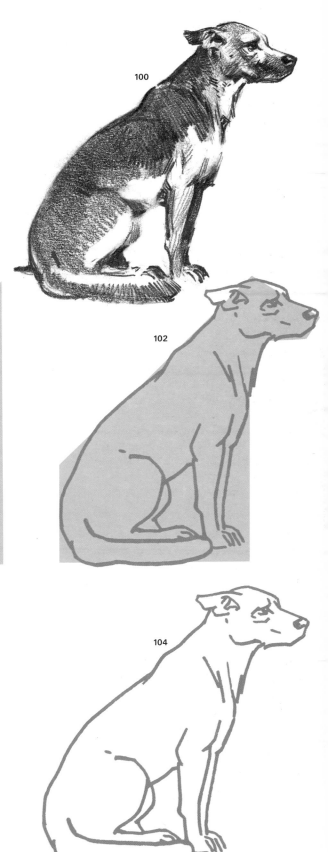

Figs. 97 and 100. We'll start by drawing a dog in the normal sitting position. The first step is to make a mental study of the subject, observing its general forms. Give particular attention to the head, noting the outline of the nose, the position and size of the eye and ear, and so on.

Figs. 98, 101 and 102. Next, try to structure the form of your subject, using a basic shape like the triangle (Fig. 101), adjusting this form by cutting off the lower left angle and adding the schematic shape of the head at the top.

Fig. 103. To complete the framing of the picture, it is also necessary to study the negative space—the shape of the background, as if you were looking at a negative photograph of the animal. You can see this clearly in Fig. 103.

Figs. 99 and 104. Finally, draw the form of the dog, taking great care with the edges of the head, the body, the legs, and so on.

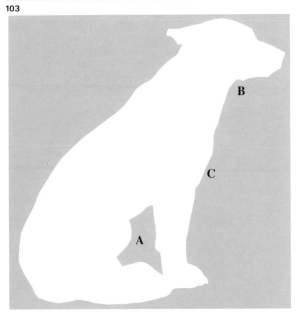

Calculating dimensions and proportions

First of all, we must define what we mean by calculating dimensions and proportions. A drawing can only be made after a preliminary study of the dimensions of the subject, its height in relation to its width, and by then proportioning the different parts of the subject with respect to the others.

Having explained this point, we can go on with our discussion of Ballestar's technique by saying that, after the period spent observing the model described on the previous page, he begins to draw, at the same time calculating dimensions and proportions. He could not do it any other way. With an unmoving model such as a landscape, a still life, or even a human figure, the artist can calculate dimensions before starting; he can observe the subject and see that "that house is higher than that tree, and lower than that mountain." But animals move. When you are drawing animals, you have to draw and measure at the same time. That is why, and I repeat and insist on this point, it is absolutely necessary to draw many, many animals in order to memorize the features of their form.

But once you are into the habit and have practiced calculating at the same time as you draw, it is not as complex or difficult as it may seem at first. Take this example: In Fig. 105 we can see the dog Escarlata drawn by Ballestar while his daughter Blanca held the animal, as we saw in Fig. 95. In Figs. 106, 107, and 108 we can see that the calculation of distances is made by comparing the height and width of the head placed to one side of, above, and below its actual position. These distances are indicated by the letters AA, BB, and CC. Figs. 109 and 110 show the points and positions of vertical or horizontal coincidence which help the artist decide dimensions and proportions—in other words, to draw.

Fig. 105. A mastery of drawing can be achieved only through preliminary calculations of dimensions and proportions, enabling us to place each part correctly in relation to all the others.

Fig. 106. The dimensions of the head give a good guideline for establishing the rest of the dog's proportions. See in this illustration how the total width of the drawing occupies a space equivalent to two heads (A-A).

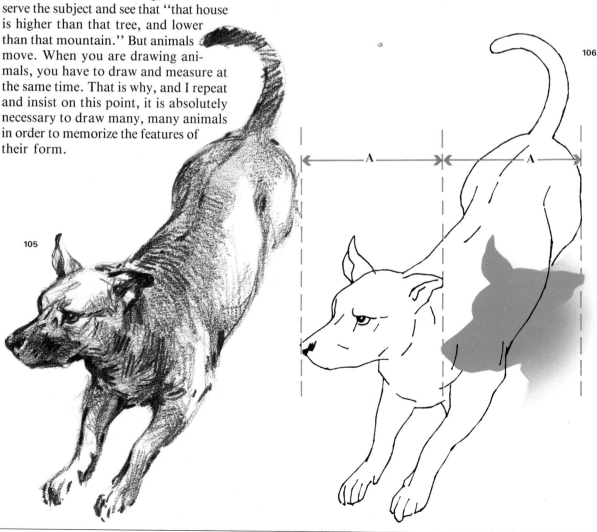

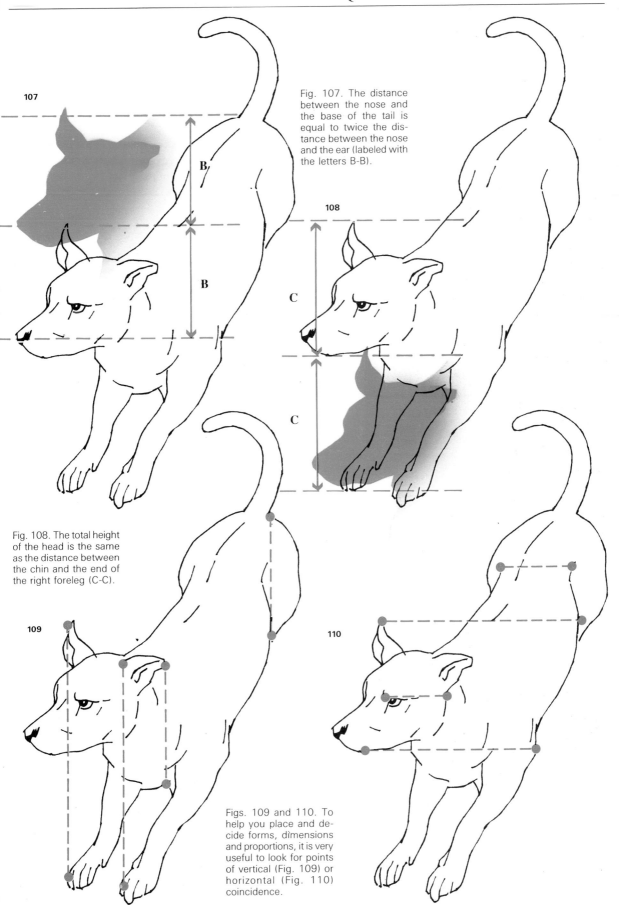

107

Fig. 107. The distance between the nose and the base of the tail is equal to twice the distance between the nose and the ear (labeled with the letters B-B).

B

B

108

C

C

Fig. 108. The total height of the head is the same as the distance between the chin and the end of the right foreleg (C-C).

109

110

Figs. 109 and 110. To help you place and decide forms, dimensions and proportions, it is very useful to look for points of vertical (Fig. 109) or horizontal (Fig. 110) coincidence.

First demonstration: a quick sketch of a dog posing

Ballestar starts drawing with the profile of the head, holding the stick of the pencil inside his hand. He then moves on to the animal's back, changing from his linear style to put in a gray. Next he goes back to linear drawing for the front leg, the outline of the stomach, and the curve of the thigh, still holding the stick of the pencil inside the palm of his hand. Now he changes, moving over to work on the head. He holds the pencil in the conventional manner, as if writing, and draws the ear, the eye, and the nose. With the pencil once more inside his hand, he adds grays to the head. He works hard to get the ear right, strengthens the broad gray of the back, and reinforces the outline of the chin, the chest, the leg, the stomach, and the thigh. Ballestar does all this with great speed and sureness of hand, often from memory, though without losing sight of his subject. The dog is continually moving, and has now changed from the sitting position at the start of the session to the lying position we can see in Fig. 119 on the next page.

And Ballestar begins this next sketch, working even more quickly and surely, with some faint reference lines that allow him to sketch decisively. He firmly intensifies and strengthens his lines, alternating, as ever, his two ways of holding the pencil. This second sketch is completed in a record time of six minutes.

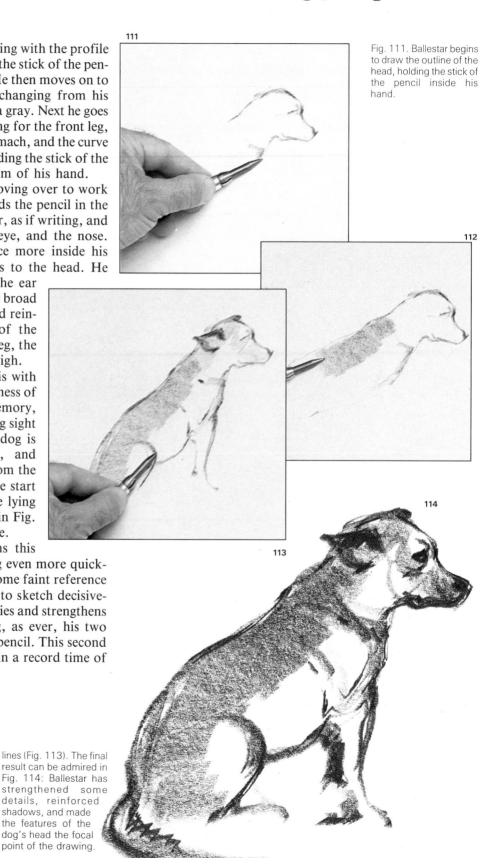

111

Fig. 111. Ballestar begins to draw the outline of the head, holding the stick of the pencil inside his hand.

112

113

114

Figs. 112 to 114. He continues drawing the back of the dog, but then interrupts this linear work to shade a gray area over the dog's flank, holding the lead at an angle to the paper (Fig. 112). Then he reinforces some lines (Fig. 113). The final result can be admired in Fig. 114: Ballestar has strengthened some details, reinforced shadows, and made the features of the dog's head the focal point of the drawing.

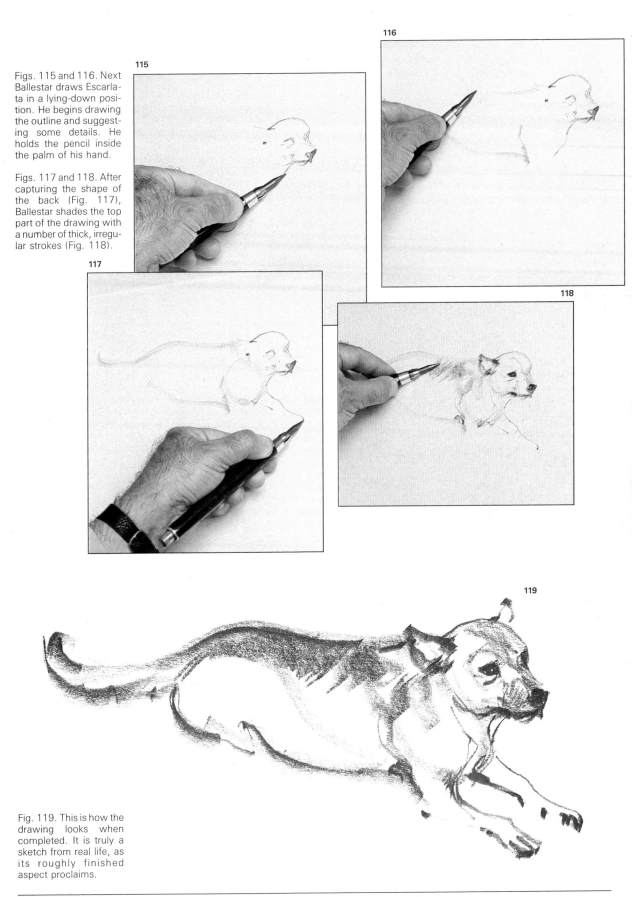

Figs. 115 and 116. Next Ballestar draws Escarlata in a lying-down position. He begins drawing the outline and suggesting some details. He holds the pencil inside the palm of his hand.

Figs. 117 and 118. After capturing the shape of the back (Fig. 117), Ballestar shades the top part of the drawing with a number of thick, irregular strokes (Fig. 118).

Fig. 119. This is how the drawing looks when completed. It is truly a sketch from real life, as its roughly finished aspect proclaims.

Second demonstration: a quick sketch of a cat posing

Ballestar is now going to paint a cat from a photograph (Fig. 121), using colored pencils.

"You shouldn't reject out of hand the idea of drawing or painting with the help of photos," our artist explains, "but you mustn't overdo it either, because too much work from photographs can make your drawing stiff or mechanical."

We can point out three technical aspects of Ballestar's rendering of this magnificent sketch:

(a) The initial drawing was done in gray pencil. You should never use lead pencil with colored pencil,

because the graphite makes the paper dirty.

(b) The cat's pose allow the artist to capture the cat's form.

(c) To suggest the texture of fur, he uses colored pencils to draw and a razor blade to scrape, in the sgraffito technique demonstrated in Fig. 127. You can also see the effects achieved with the razor blade in the highlights in the cat's eyes and in its whiskers.

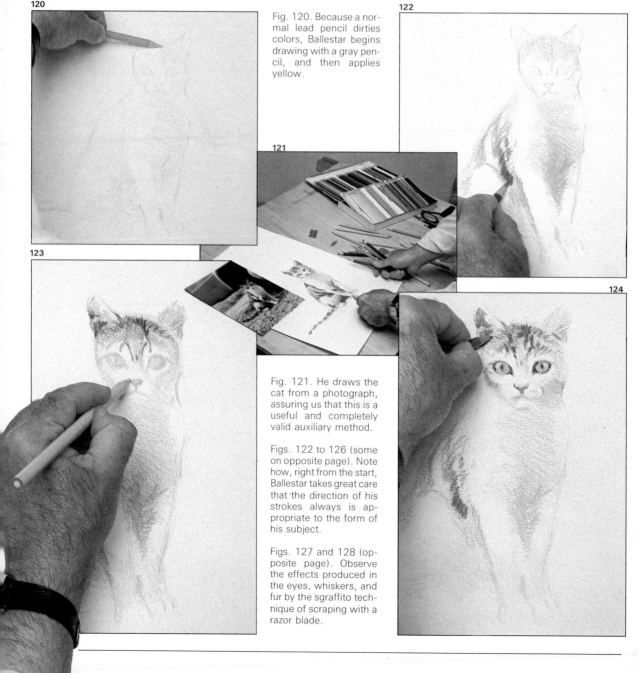

120

Fig. 120. Because a normal lead pencil dirties colors, Ballestar begins drawing with a gray pencil, and then applies yellow.

122

121

123

124

Fig. 121. He draws the cat from a photograph, assuring us that this is a useful and completely valid auxiliary method.

Figs. 122 to 126 (some on opposite page). Note how, right from the start, Ballestar takes great care that the direction of his strokes always is appropriate to the form of his subject.

Figs. 127 and 128 (opposite page). Observe the effects produced in the eyes, whiskers, and fur by the sgraffito technique of scraping with a razor blade.

125

126

127

128

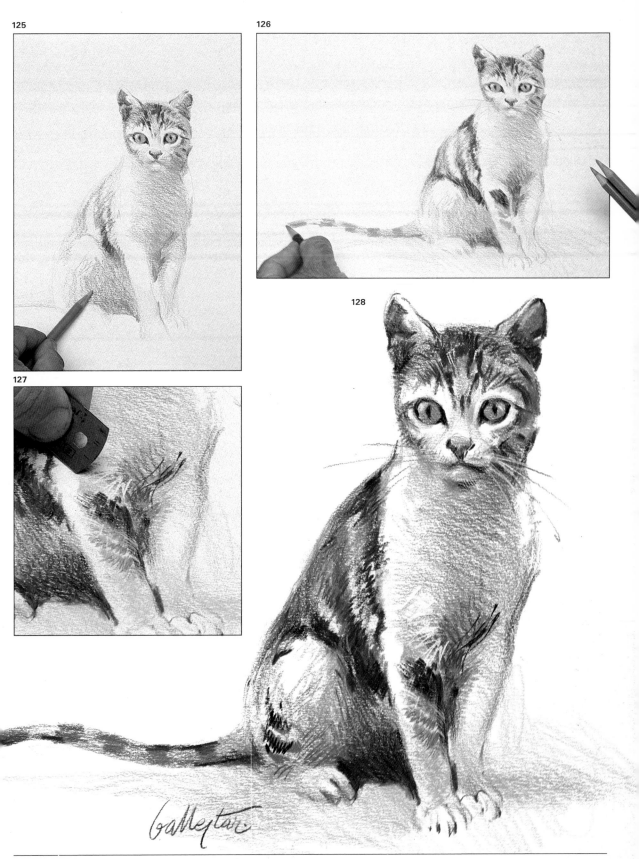

Now we are going to paint, but first we will review color theory by talking about light colors and pigment colors and about primary, secondary, and tertiary colors. Thanks to the English physicists Newton and Young, we know that it is possible to paint all the colors of the spectrum from just three: the primary pigment colors of cyan blue, magenta, and yellow. Then we will get down to business, painting first with just two colors, then with the three mentioned above, proving that Newton and Young were right. Finally, we will talk about materials for drawing and painting: lead pencils, charcoal, pastels, pen and ink, writing cane, wax crayons, colored pencils, watercolor, oil, and acrylic. This interesting and practical chapter will reinforce your knowledge of painting in general and painting animals in particular.

COLOR THEORY
APPLIED TO PAINTING
ANIMALS

Color theory applied to painting animals.
Painting with just two and three colors.
Materials for drawing and painting.

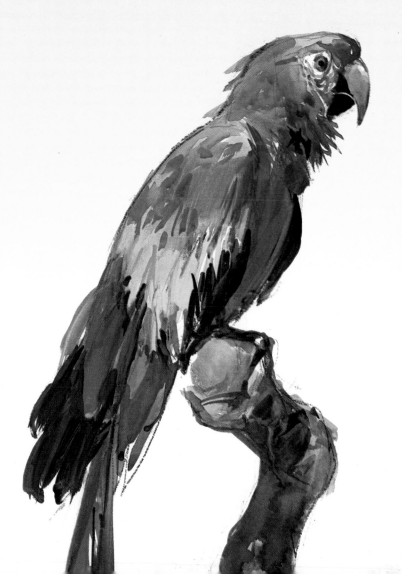

All colors from just three colors

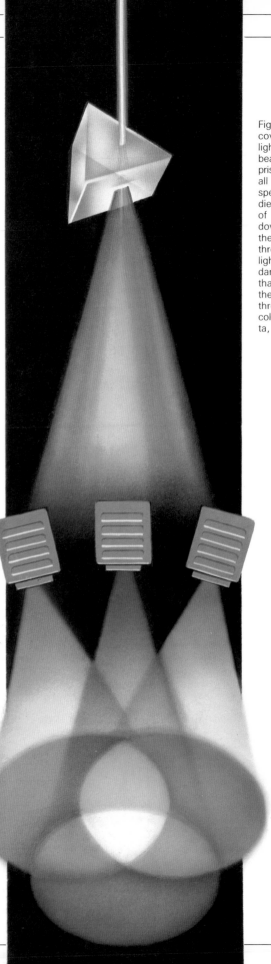

Color is light. About two hundred years ago, the English scientist Isaac Newton proved this theory by shutting himself up in the dark and intercepting a beam of light with a prism, dispersing the white light into all the colors of the spectrum. One hundred years later, another physicist, Thomas Young, experimenting in the same field, projected the light of several lanterns onto a white wall. Each lantern had a different-colored glass representing the six colors of the spectrum. By changing and taking out different beams, he reached a new and definitive discovery: that with only three colors—red, green, and dark blue—it was possible to reconstruct white light. This explains what a primary color of light is, for if all colors can be reduced to just three, these are surely the basic, primary colors.

During his reconstruction of white light, Young also proved that by projecting the red beam over the green, he obtained yellow, that blue over red produced magenta, and that the dark blue over green made cyan blue. This explains why we call these three colors of light secondary: They are second in order, obtained by mixing the primary colors (see Fig. 131). Well, up to this point we have spoken of light—of beams of light, of dispersing and reconstructing white light. This is why mixing or adding colors—such as green and red—doubles the amount of light, giving a brighter light, yellow. Physicists call this additive synthesis. But we do not paint with light. We paint with pigments, which absorb some colors of light and reflect others back to our eyes. The more pigments are there, the more colors they absorb, and the darker the resulting color will be. This is why our mixtures of color always mean taking away light. With red and green pigments we get brown, a darker color. Physicists call this subtractive synthesis. So our primary pigment colors are brighter than primary colors of light.

Fig. 129. Newton discovered that color is light by intercepting a beam of light with a prism, dispersing it into all the colors of the spectrum. Young studied the composition of light by breaking down all the colors of the spectrum into just three primary colors of light: red, green, and dark blue, and found that by mixing pairs of these he obtained the three secondary light colors: yellow, magenta, and cyan blue.

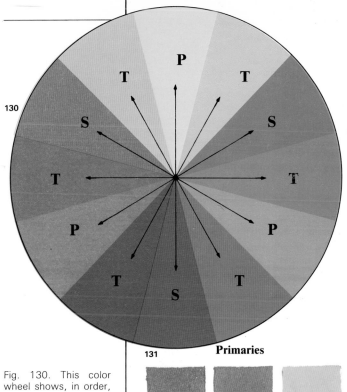

130

Fig. 130. This color
wheel shows, in order,
the primary pigment
colors (P), the secondary
pigment colors (S), and
the tertiary pigment
colors (T).

Fig. 131. PIGMENT
COLORS. Primary:
magenta, cyan blue,
yellow.
Secondary: dark blue,
green, red.
Tertiary: orange, car-
mine, violet, ultramarine
blue, emerald green,
light green.
These six color samples
show red mixed with
black (above) and red
mixed with white (be-
low). Any color has an in-
finite range of shades
and tints obtainable in
this way.

Fig. 132. The practical
conclusion of these the-
ories is that, from just the
three primary colors, we
can make all the colors of
the spectrum.

131

Primaries

Secondaries

Tertiaries Red + Black

Red + White

132

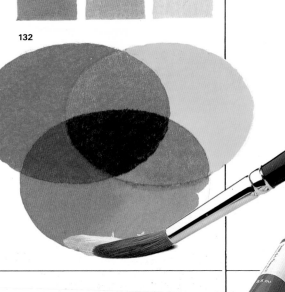

In fact, the primary pigment colors are
the secondary light colors, and, in turn,
the secondary pigment colors are the
primary light colors.
These, then, are our primary pigment
colors:

Yellow, magenta, blue.
The mixture of pairs of these produces
the secondary pigment colors:

Dark blue, green, red.
The mixture of the secondary colors with
the primaries make the tertiary pigment
colors:

Light green, orange, violet, carmine,
emerald green, and ultramarine blue.
We can paint with all the colors of na-
ture with just three colors of pigment:
yellow, magenta, and blue.
The color wheel and the table of pigment
colors reproduced on this page show the
three primary colors (P), which, when
mixed together, produce the three secon-
dary colors (S). Mixing primaries with
secondaries gives us the six colors known
as the tertiary colors (T).

Painting with just two colors

133

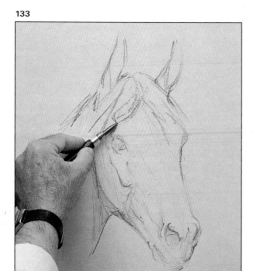

It may seem impossible, but it is true: Ballestar painted the head of this horse (Fig. 138) with just two colors, English red and ultramarine blue. With the help of the white of the paper and by mixing the two colors, he obtained this magnificent color range of black, grays, siennas, and even that color in the eye of the horse, which is almost a red.

As you can see in this step-by-step sequence of illustrations, Ballestar painted almost always with a flat brush some 3/4 inch (2 cm) wide, except for detail or small forms such as the eye or the nose (Figs. 136 and 137). Observe in Figs. 134 and 135 the sharpness and spontaneity of the brushstrokes, the product of

Figs. 133 to 138. In painting this horse's head, Ballestar used just two colors: English red and ultramarine blue (Fig. 138). By mixing the two in different proportions, he obtained the warm range of chestnut colors we can see here, varying in intensity according to the needs of modeling the picture.

134

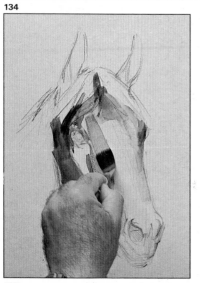

135

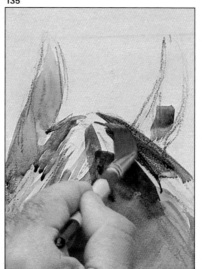

136

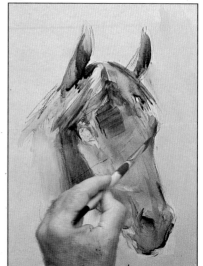

137

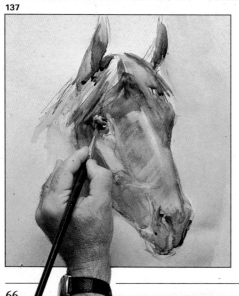

Ballestar's sureness of hand. We can appreciate this in the finished picture.
I recommend that you paint this picture using just the two colors mentioned above. It will be an excellent practical exercise, helping you to master watercolor techniques and to memorize the forms of the horse's head.

138

139

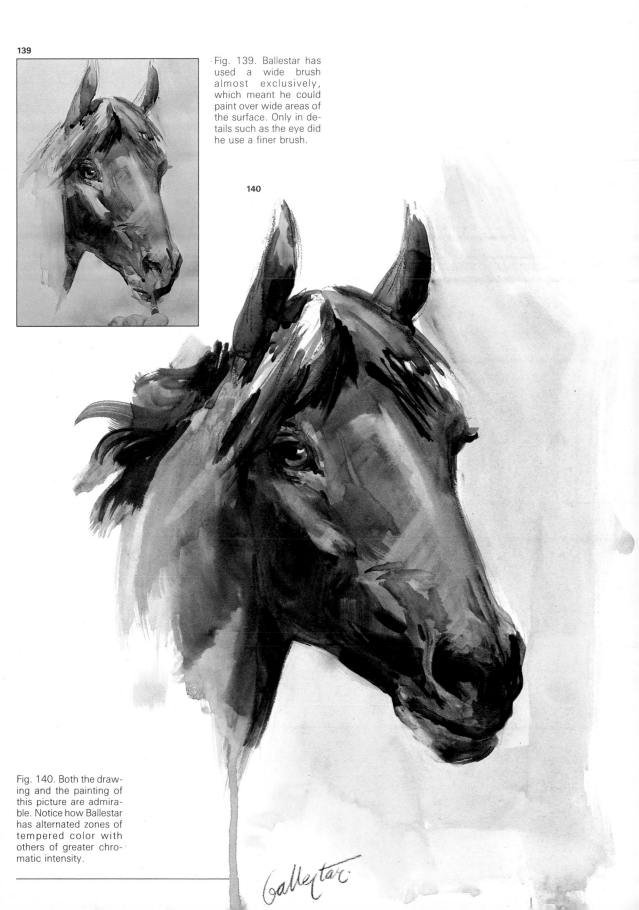

Fig. 139. Ballestar has used a wide brush almost exclusively, which meant he could paint over wide areas of the surface. Only in details such as the eye did he use a finer brush.

140

Fig. 140. Both the drawing and the painting of this picture are admirable. Notice how Ballestar has alternated zones of tempered color with others of greater chromatic intensity.

Painting with just three colors

Figs. 141 to 143. Having drawn the figure of the macaw (Fig. 141), Ballestar begins painting, using rather light tones—yellow and a mixture of the same color with carmine (Fig. 142). To give the effect of volume, our artist deepens the orange-red color with pure carmine (Fig. 143).

Fig. 144. Ballestar renders this painting with only yellow, carmine, and ultramarine blue, using a porcelain plate to mix his colors, with the splendid results we can see in Fig. 148.

Lemon yellow, carmine, and ultramarine blue are the only colors used by Ballestar to paint this macaw from a photograph I myself took at the zoo.

Both when painting this picture of the macaw and when painting the horse on the preceding page, Ballestar used a china plate as a palette. I ask him about this and he tells me:

"I don't like pans or palettes made of porcelain, much less of plastic." He starts to draw with a lead pencil, continuing, "I always paint with the palette in my watercolor paint box, but when I have to paint something with two or three colors, I like a china or porcelain plate.

Ballestar starts to paint with a mixture of carmine and yellow, obtaining an orange (Fig. 142) that he immediately intensifies with pure carmine (Fig. 143) and a tiny amount of ultramarine to suggest volume. Then he paints the yellow part of the bird and the long rust-colored tail (Fig. 145), moving on then to the head, where he paints the beak and begins to work on the color of the eye (Fig. 146). He finishes the head, first absorbing red paint to widen the yellow area (Fig. 147). This he does with the brush squeezed almost dry. When this cleaned area is dry, he will repaint in pure yellow.

The artist moves over the picture all the time, painting in one part before mov-

141

142
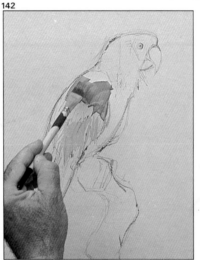

143
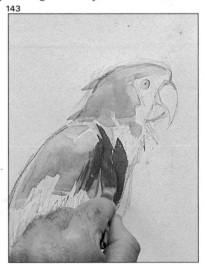

144
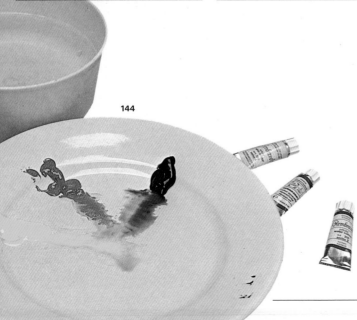

ing on to another section, alternating forms and colors. He also alternates between flat brushes and the number 6 round brush, painting thicker strokes with the flat brush and repainting and defining form with the thinner round brush. For the eye and other details, he paints with an even thinner number 3. He lingers over the upper tail feathers of his subject, first painting them in a reddish tone that sets off the tail, then painting them a dark ultramarine blue. He darkens the end of the tail so that, through an effect of simultaneous contrast, the blue is more full of light. Finally, after finishing the body of the bird, Ballestar signs his work.

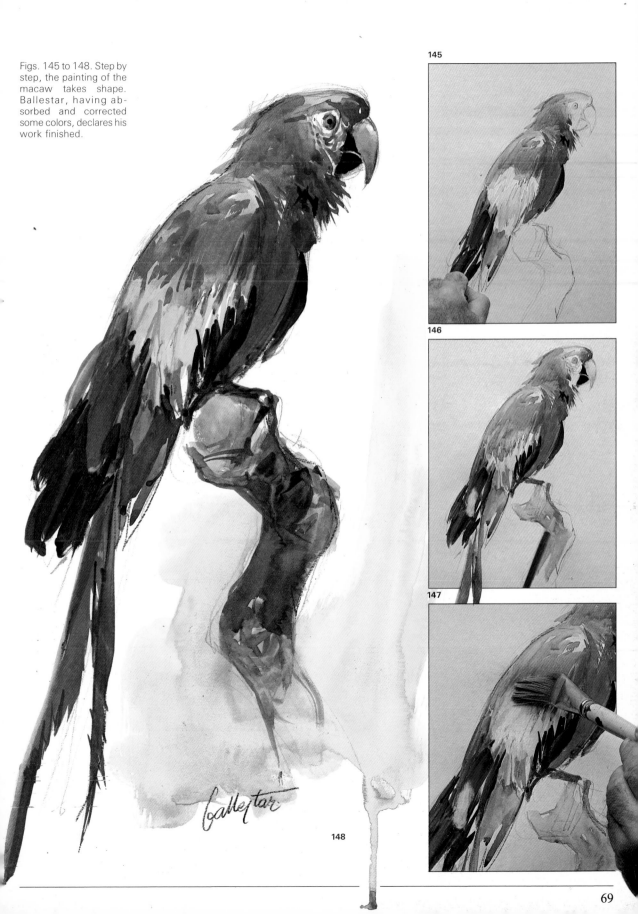

Figs. 145 to 148. Step by step, the painting of the macaw takes shape. Ballestar, having absorbed and corrected some colors, declares his work finished.

145

146

147

148

Materials for drawing and painting

Paper and pencil are the first requisites for drawing. You can draw with paper of the highest quality or with paper of such low quality as wrapping paper, but I would recommend medium-grain paper, thick enough to stand up to the rubbing of an eraser. Some of the best-known makes of suitable paper are Canson, Arches, Fabriano, Whatman, Schoeller and Grumbacher. Pencils can be graphite or lead sticks, and should be soft. A set of four pencils (an HB, a 2B, a 4B, and a 6B) is enough, and can be made by Faber, Koh-I-Noor, Cumberland, Staedtler, and so on. Faber's all-lead pencils are an interesting option, with diameters of up to 3/16 inch (5 mm). There is also the special mechanical pencil like the one used by Ballestar, which you can see in Fig. 149A. And a recent addition to the market: a lead pencil that can be mixed with water, and which we will see in action later.

Other classic drawing materials are charcoal pencils or sticks with characteristics similar to those of pastel sticks (Fig. 149B). Then there are chalk sticks, sometimes called Conte crayons (C), available in white, black, gray, sanguine, sepia, and many more colors. These are available from Faber, Koh-I-Noor, Caran d'Ache, and so on. We can also mention stumps (D) and flexible plastic erasers.

For vibrant color, there are soft pastels (E), made by different companies such as Rembrandt, Schmincke, Faber, Caran d'Ache, Lefranc, Grumbacher and others. These come in wide color ranges, in boxes of 18 colors or fine assortments of 99, 163, even 336 different colors! Colored paper works very well with chalk or pastels, a recommended brand being Canson Mi-Teintes.

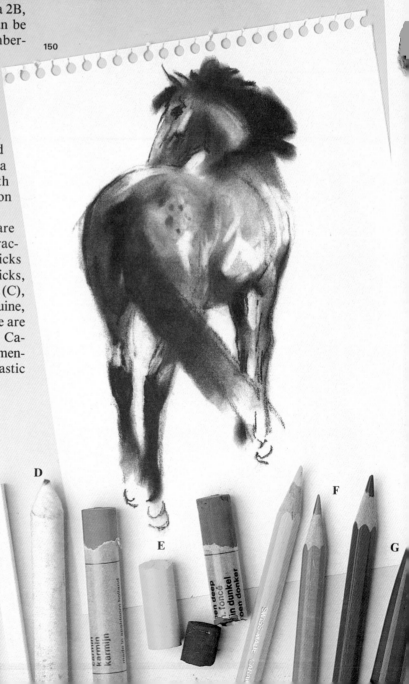

151

150

149

A

B

C

D

E

F

G

Colored pencils (F) are available in assortments of up to 60 or 72 colors. They can also be used on colored paper. Still more material: ball-point pens (G); the writing cane (H) for drawing with India ink and which can be used to produce works of the highest quality. Next we have the fountain pen (I), also for drawing with India ink, and the brush (J) to paint with gouache or to draw with India ink. For ink a mongoose-hair brush is more suitable than a sable-hair brush. Wax crayons or oil pastels (K) give splendid results in drawings or paintings, as we see in Ballestar's rooster (Fig. 152).

152

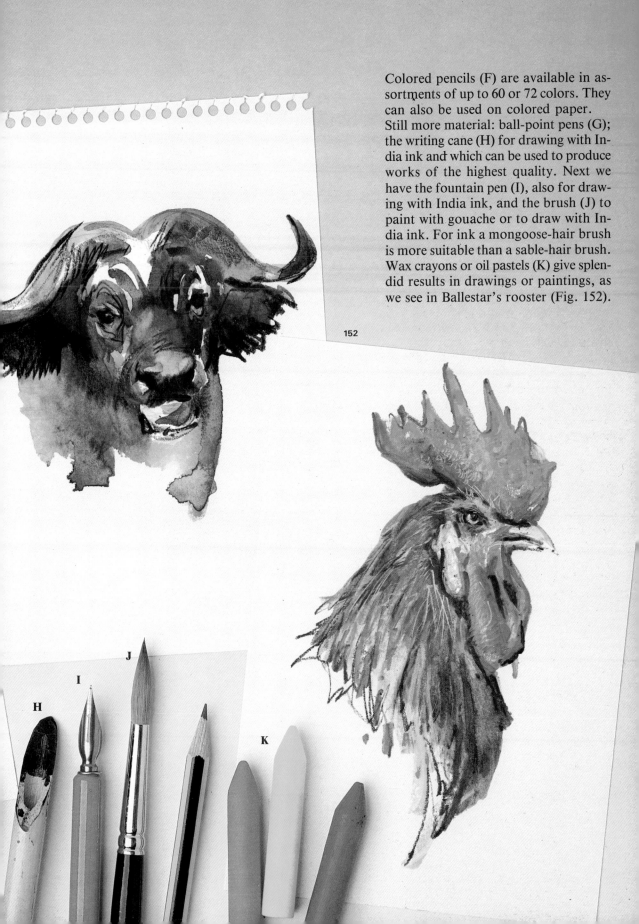

Materials for painting

Watercolor, gouache, acrylic, and oil are four types of painting with which Ballestar finds himself equally at home, though he prefers watercolor.

Apart from the low-quality dry watercolors used in schools, professional watercolors come in pans of wet colors, in tin tubes of creamy watercolors, and in jars of liquid watercolors.

Ballestar paints both with wet pans and with creamy watercolors packed in tubes. As you know, watercolors are sold in boxes that also serve as palettes, with from 12 to 36 pans in each. Winsor & Newton offers miniature boxes for painting sketches, an example of which you can see in figure 153A. Palettes are also available separately. Creamy colors are shown in figure 153.

Gouache colors come in pans, tin tubes, and small glass jars. Gouache colors differ from watercolor in that they are more opaque, covering the paper more than the transparent watercolors. The two can be combined in painting, and in fact many artists do this.

The most suitable brushes for watercolor are those of sable hair. For gouache, use sable-hair, mongoose-hair, or sow-bristle brushes.

154

153

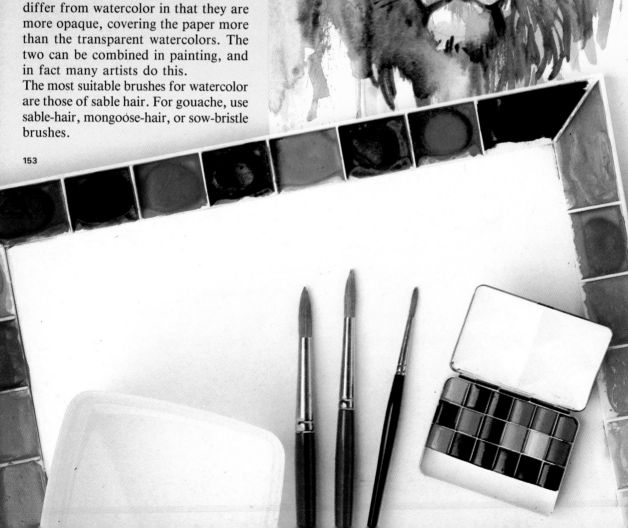

156

Acrylic painting is synthetic, combining the techniques of watercolor and oil painting. Acrylics are diluted in water and can be applied as a transparent covering like watercolor or in thick layers like oil paint. Acrylic paint dries relatively quickly and, once dry, is not water-soluble. This drawback can be counteracted by adding retarding liquid to the water. Any surface can be painted with acrylics, but wood has to be prepared with a special priming material. Any dry paint that remains on the brush can be washed off with acetone.

Oil painting is characterized by the rich variety of tones obtainable by mixing different colors. It is an opaque paint that comes in tin tubes and can be used on any surface. The most traditional is canvas, mounted and stretched on a wooden frame. To dilute oil paint, linseed oil or turpentine is used. The colors are generally set out on a palette. The most suitable brushes are those of sow bristles, though for small details, a sable-hair brush can also be used.

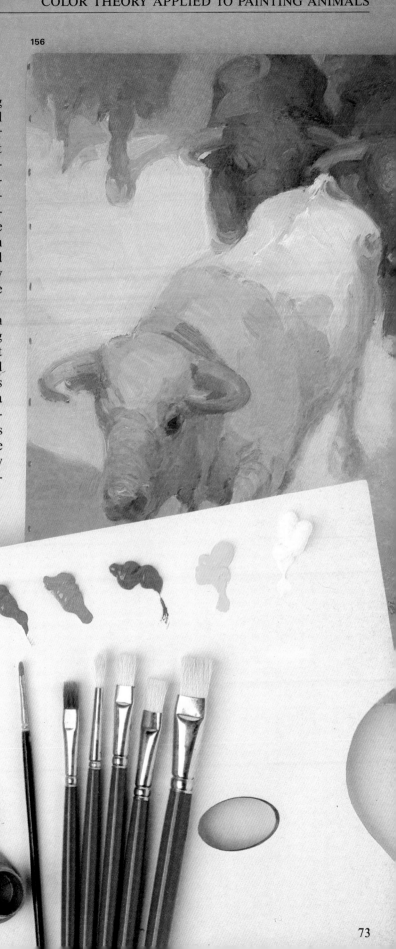

155

Through a step-by-step series of sketches and demonstrations, in this chapter we will show how to make a quick sketch of an animal in motion. This problem requires a broad knowledge and a great capacity to memorize the form of animals. Ballestar will paint in watercolor, and his first subject will be Escarlata the dog, walking. Then we will go into the country, to a farm, where our artist will paint rabbits, hens, cocks, ducks, pigs, cows... and I will observe and dictate what he does. He will draw with a normal lead pencil and with one that can be mixed with water. He will also paint in watercolor, with colored pencils, and with wax crayons. This chapter is packed with practical teaching.

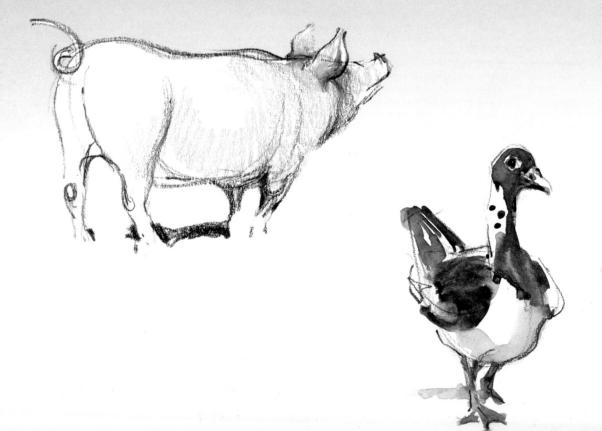

SKETCHING ANIMALS IN MOTION

Painting a dog and various other animals in motion, at home and on the farm, using different materials for drawing and painting.

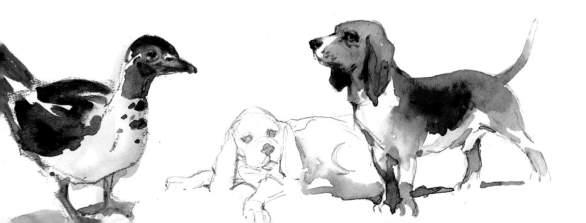

A sketch of Escarlata walking

We go back to the house of Ballestar's daughter Blanca, to draw and paint her dog, Escarlata.

Ballestar explains: "'I'm going to paint her walking." And he turns to me and my cassette player, and adds, "I'll have to observe her for a time, while Blanca calls her and she walks around answering her commands."

Thank you, Blanca, for spending almost a quarter of an hour calling Escarlata and going from here to there and back, with the dog walking up and down in front of Ballestar. The artist is absorbed, concentrating, observing with absolute attention, even moving his pencil over the paper in a sort of rehearsal, but not, as yet, beginning to draw.

Then, all at once, he has started! With pencil in hand, he quickly draws the head, almost in just one continuous line, without lifting the pencil from the paper. Next he moves from the head down to the neck, the back, and the thigh. Ballestar is pensive, drawing, looking at the drawing paper and the dog ... paper and dog ... paper and dog. Without lifting his head, he takes hurried looks, drawing what he sees in each glance.

He finishes the sketch and says:

"That's it. Now for the problems of the painting, the technical problems."

He is using a synthetic-hair round brush, a number 10. He explains: "I'm going to paint the whole time with this brush, except for a few details which I'll do with a thinner one, a number 4."

He starts painting, with a mixture of sienna, ochre, and red (Figs. 158 and 159). Getting down to the thigh and the tail, he adds ultramarine blue to the mixture (Fig. 160). The color on his palette is now a dirty, dark sienna-gray, with which he now paints wet-on-wet the dog's nose, then his ear and a few strokes to give shape to the neck below the ear. (Note in Fig. 161 how Ballestar holds the brush, from very high up, to move it more widely, giving a looser touch.) Finally, with the number 4 brush, Ballestar draw-paints the the face of the dog.

157

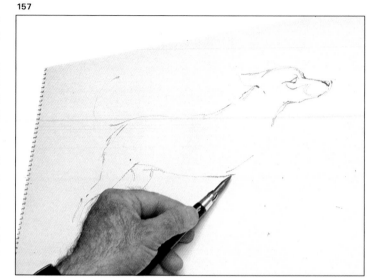

158

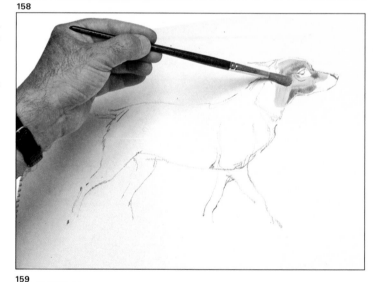

159

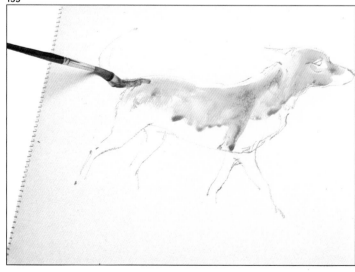

Figs. 157 to 162. No words could explain how Ballestar works better than this sequence of images, terminating in the completed painting reproduced in Fig. 162.

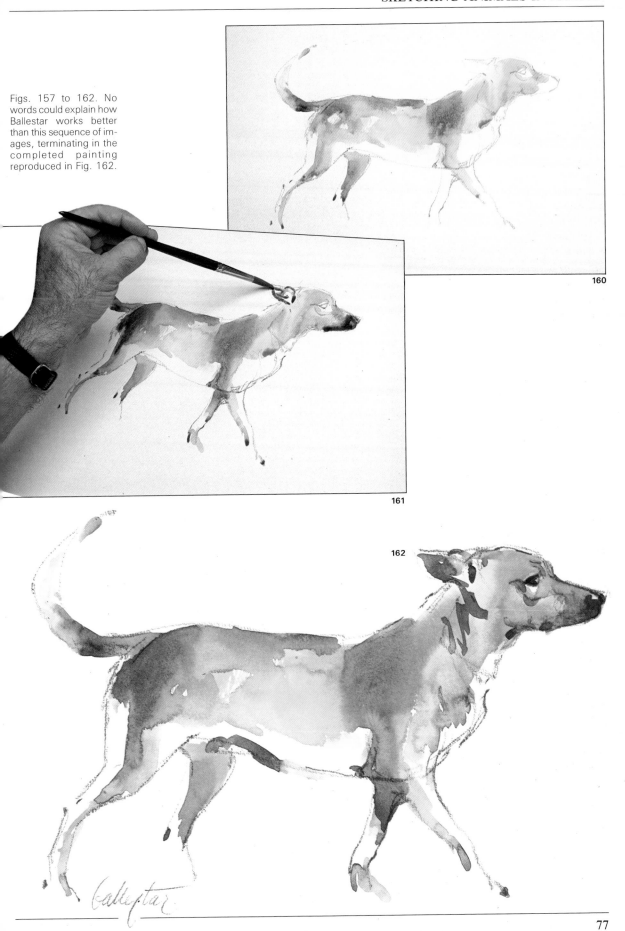

160

161

162

Sketching animals on the farm

163

Here we are, on the farm, as you can see in Fig. 167, a typical mountain farm with roosters, hens, chicks, ducks, and ducklings running free, pecking here and there around us.

Ballestar opens this session by making a number of lead pencil sketches, from which we choose one of a hen walking and another of a rabbit sitting down (Figs. 168 and 170).

Now he takes his wax crayons and with a dark sienna paints a hen (Fig. 171). In it, you can see the effect of the razor blade thinning the color by scrapings, or sgraffitos. In some cases these are just fine lines or traces but in others they appear like brushstrokes or broad lines.

Next he gets out his watercolors and paints three ducks, the first two in profile and the last in three-quarter position (Figs. 169, 172 and 174). He uses three brushes, a 3/4 inch (2 cm) flat brush and a round brush, both of synthetic hair, and a sable-hair round brush, a number 4, for small details.

These are white ducks with black backs and occasional marks. He paints with ultramarine blue mixed with black, painting the feathers in synthesis, so that each stroke of the brush represents a feather. The belly he paints with a light gray gouache, and the forms around the eyes and beak with English red. The form and yellow color of the legs and

164

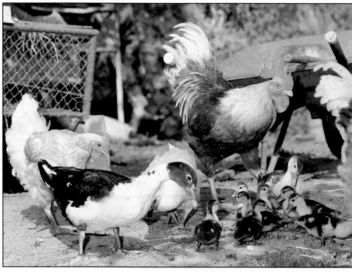

Figs. 163 to 174. Hens, rabbits, ducks, pigs... Ballestar paints them all with surpassing mastery, producing this brilliant series of sketches drawn and painted on the farm.

165

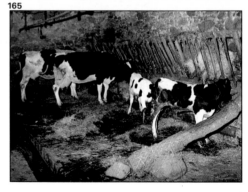

166

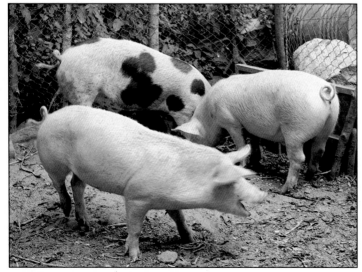

feet he achieves with just one brushstroke.

We move on to the pigsty, where Ballestar will complete this first sketching session. He sets himself the challenge of drawing a pig seen from behind, a task he accomplishes with colored pencils.

"Now I'm going to paint a couple of these black and white ducks, this time taking it much more slowly."

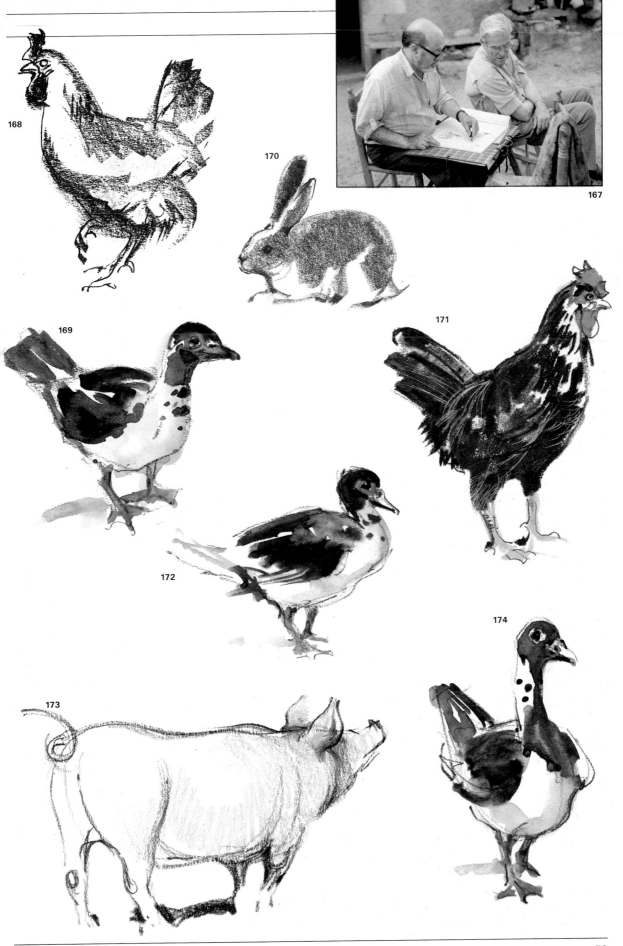

168

170

167

169

171

172

173

174

Ducks in watercolor

(Not a typical local delicacy, whatever it may seem from the title of this section!)

With the same brushes mentioned on page 72 and with a very limited color range, our guest artist is going to paint two of the ducks that are wandering freely around the farm.

You can see the simplified form of these two animals in the schematized diagrams in Figs. 175 and 181. Follow the process of the step-by-step development of these paintings in Figs. 176 to 186, and note Ballestar's concern to represent the feathers of the ducks with different brushstrokes. Study, too, the tremendous simplicity of forms and colors, which takes as its starting point a well-constructed drawing and a capacity of synthesis that can be acquired only after much practice, after drawing and painting animals time and time again.

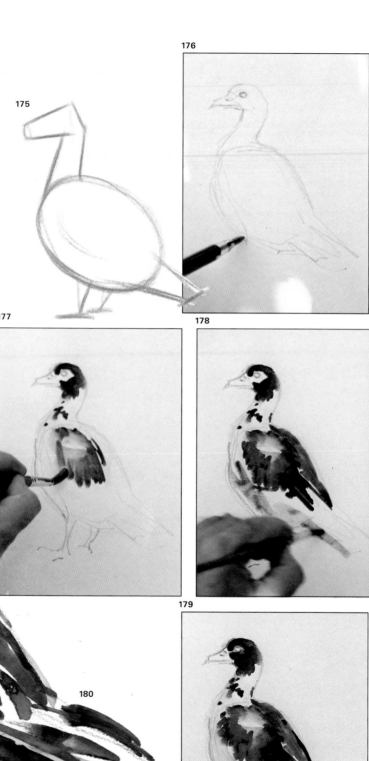

175

176

177

178

179

180

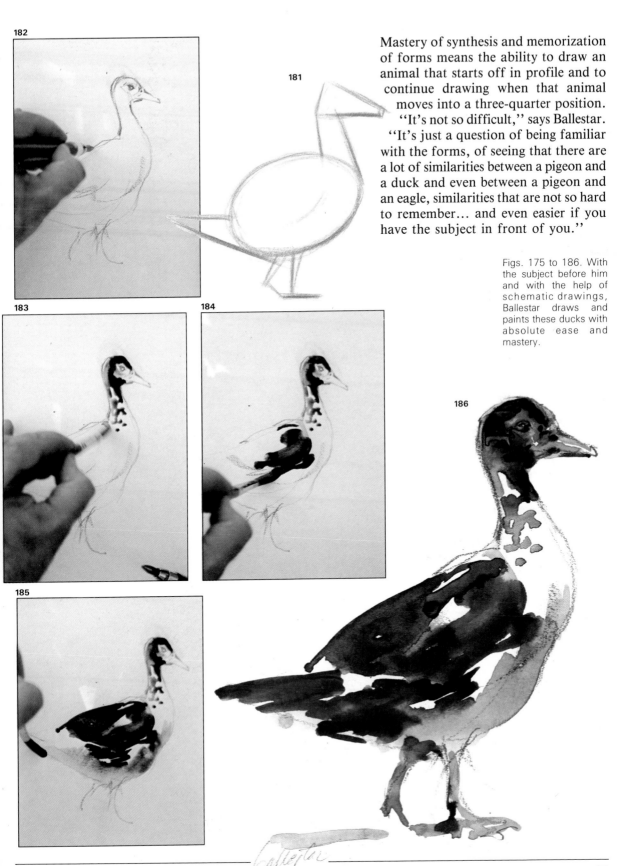

182

181

183

184

185

186

Mastery of synthesis and memorization of forms means the ability to draw an animal that starts off in profile and to continue drawing when that animal moves into a three-quarter position. "It's not so difficult," says Ballestar. "It's just a question of being familiar with the forms, of seeing that there are a lot of similarities between a pigeon and a duck and even between a pigeon and an eagle, similarities that are not so hard to remember... and even easier if you have the subject in front of you."

Figs. 175 to 186. With the subject before him and with the help of schematic drawings, Ballestar draws and paints these ducks with absolute ease and mastery.

A cow in water-soluble pencil and a pig in colored pencils

We are now standing in the barn, looking at some cows and calves. The light is very bad, but there is just enough for Ballestar to draw one of these creatures. He does this with a special lead pencil that can be made to give the effect of watercolor by painting over grays or gradations with a sable-hair paintbrush dipped in water. You can see it in Figs. 187 to 191.

The watercolor pencil used by our artist to draw this cow is made by the English firm of Rexel Cumberland under the name "dark wash," and is available in HB, 4B, and 8B.

Observe in the finished work just what you can do with a pencil, a brush, and some water (and the ability and skill of Ballestar).

187

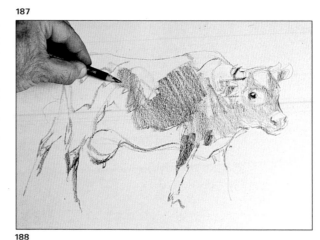

188

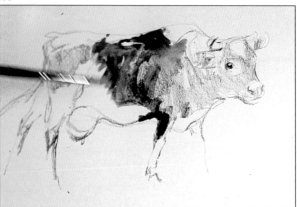

189

Figs. 187 to 191. The "dark wash" pencil made by Rexel Cumberland enables the artist to create washes similar to those of watercolor painting (Fig. 190), producing such interesting results as the finished drawing in Fig. 191.

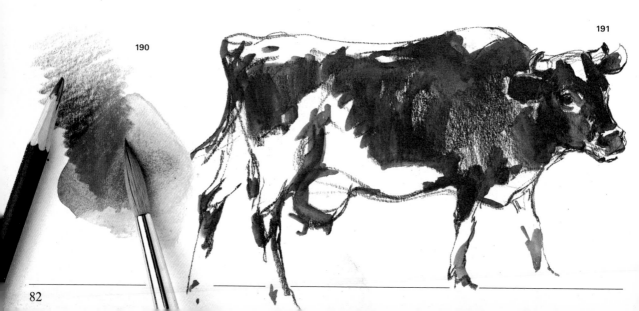

190

191

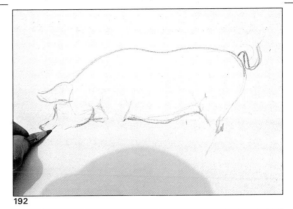

192

Now we go back to the pigsty. Ballestar is going to paint a pig in colored pencils. Just a few colors: black, sienna, yellow, ochre, pink, and a few touches of blue for the areas in shadow. Not many pencils compared with the 72 different colors in the Cumberland pencil box that Ballestar shows me with pride.

He draws first with the black colored pencil (Fig. 192). Note the step-by-step process as he gradually draws through successive layers that build up both color and form. It is more a drawing than a painting, given the bold outline and the lines that convey the animal. Ballestar must choose the direction of his lines with great care.

"The lines must define the form," Ballestar emphasizes.

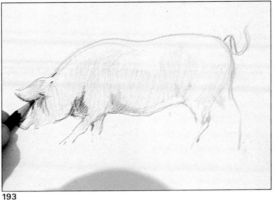

193

Figs. 192 to 197. Ballestar uses a black pencil to complete the preliminary sketch before coloring his picture (Fig. 192). He then uses pink, sienna, yellow, and ochre to magnificent effect, as you can see in the finished version (Fig. 197).

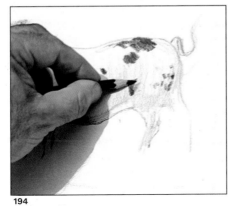

194

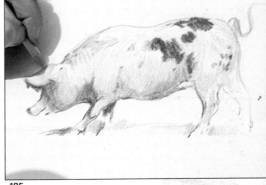

195

196

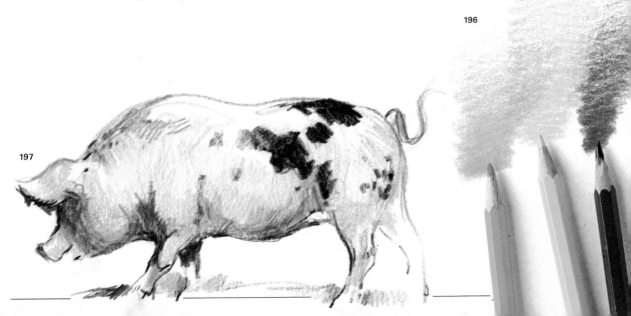

197

Painting a hen in wax crayons

We are now in the henhouse, a typical construction surrounded by wire held up by thick stakes, enclosing a space of some 11×11 yards (10×10 meters) in which roosters and hens strut, peck, run, and jump as if in total liberty. Ballestar, the photographer, and I have settled ourselves in here to work more comfortably. Well, not really comfortably.

Ballestar chooses a hen with a characteristic black and white feathering (Fig. 200). He draws the outline with a black wax crayon and uses the same one to draw a series of curving parallel lines. Together with some dark areas in the tail, under the wings, and at the top of the neck. These preliminary lines give a general definition of the form of the hen.

Next he adds some touches of gold ochre, which he finishes off by scraping with the razor blade. He finishes the outline, draws the tail, and paints the crest in red, finally drawing the eye, the details of the head, and the legs.

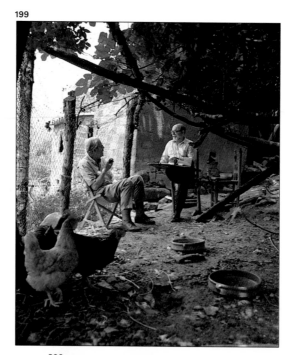

199

Figs. 198 and 199. In the henhouse, among the hens (Fig. 199), Ballestar finds the ideal place to produce some interesting pictures using wax crayons and a razor blade (Fig. 198).

200

198

201

202

203

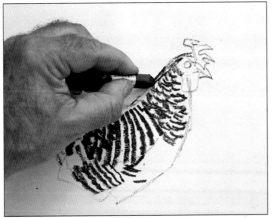

204

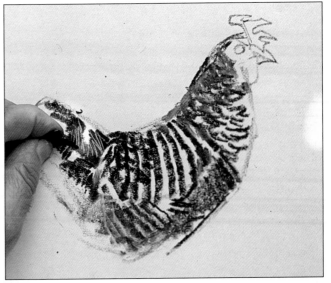

205

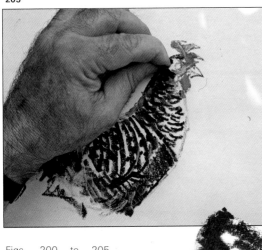

"And after that," Ballestar interrupts to add, "it was just a problem of synthesis and graphics—things you learn, or can learn, by working hard and doing a lot of drawing."

206

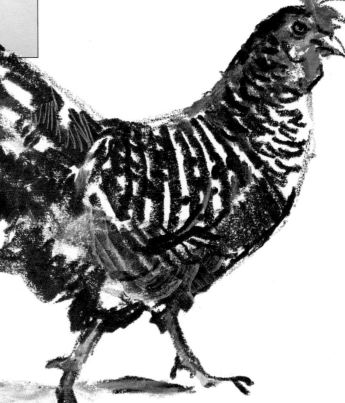

Figs. 200 to 205. Ballestar has chosen this colorful hen with its striped plumage (Fig. 200). He draws and paints with browns and ochres, producing rich graphic effects (Figs. 202 and 203) which he later elaborates with the use of a razor blade (Figs. 204 and 205).

Fig. 206. The result is a loose, agile and spontaneous piece, completed with the extraordinary ease of the expert artist.

Painting a rooster in watercolor

If you look at Fig. 199 on page 84, you will see the photograph of Ballestar and myself sitting in the henhouse, Ballestar with his legs crossed, holding a portfolio across his knee like a table. That is how, with his Schoeller block of drawing paper on his portfolio, our artist drew the hen in wax crayon, and that is also how he is going to draw the proud rooster you can see in the photograph in Fig. 207 on this page.

After drawing the bird with a black colored pencil—"the first I came across in my materials box," say Ballestar—he mixes a very light gray gouache and, surprisingly, paints a few strokes in the part corresponding to the tail of the rooster. "It is to try out how the portfolio serves as a table and to see whether I can paint in this position," Ballestar explains. Then he immediately starts to paint with a mixture of yellow, ochre, sienna, and red, adding a little Hooker's green for some sections of his picture. He uses only the synthetic-hair flat brush. "It's so old that even the varnish on the handle has started to come off," Ballestar comments.

207

Fig. 207. This is the next subject chosen by Ballestar: a proud, brilliantly colored rooster.

Figs. 208 to 211. Ballestar uses a black colored pencil for the preliminary drawing, and then begins to paint with a mixture of yellow, ochre, sienna, and red, reserving a number of white areas.

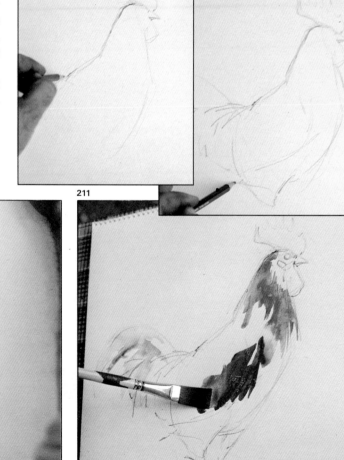

208

209

210

211

Well, he paints practically the whole of the rooster's body with this flat brush, occasionally holding it flat to the paper but more often sideways, drawing in the direction of the feathers. He also reserves white spaces that will later express volume, highlights, and reflections in those parts that are in the light (Fig. 212). He also uses the wet-on-wet technique, applying color to areas not yet dry and thus obtaining a fusion and gradation, a mixture of colors on the paper.

He ends this first phase by painting the rooster's crest, first using red, and then carmine over it while it's still wet. For this he has changed his brush, working now with the number 12 sable-hair round (Figs. 214 and 215).

212

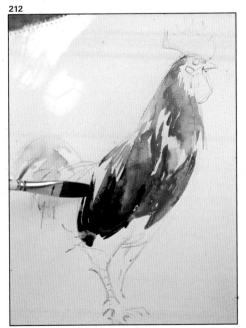

213

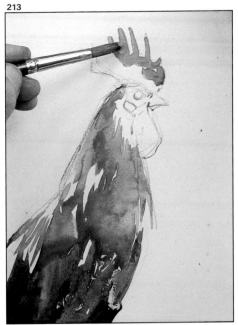

214

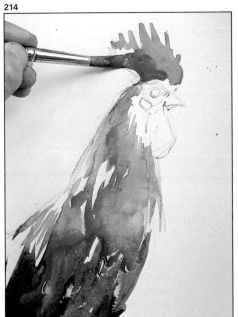

215

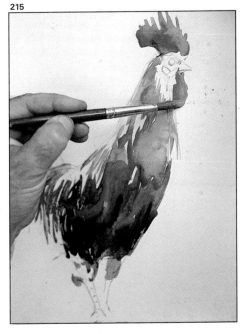

Figs. 212 to 215. To contrast with the light tones, Ballestar covers an ample area with a dark tone, which blends into the reddish color above it (Fig. 212). Changing his flat brush for a round one, he then paints the rooster's crest, first with red and then with carmine (Figs. 213 to 215).

Painting a rooster in watercolor, final phase

Figs. 216 to 219. Ballestar has painted the breast, the body, and the crest, which leaves the eye, the feet, and the tail still to paint. He uses a pinkish tone for the head, carmine for the eye (Figs. 216 and 217), yellow darkened with sienna for the feet (Fig. 218), and a gray gouache for the tail (Fig. 219).

There is little left to do now. Ballestar is still working with the number 12 sable-hair round brush, finishing the head, the beak, the eye, then the legs in yellow and ochre, and finally the tail.

It is quite something to see how he paints the tail. Imagine the brush dipped heavily in the gray color, and our artist holding it perpendicularly to the paper, gripping the brush at the top of the handle.

His hand and forearm move in unison as he paints in the feathers of the tail in that curved direction, just as Oriental artists do when painting in sumi-e style. Ballestar hears what I am dictating and comments: "Yes. Once, when I was at the zoo painting an ostrich, someone behind me said in a foreign accent, 'You paint like a Zen, sir.' I turned round and it was a Japanese."

216

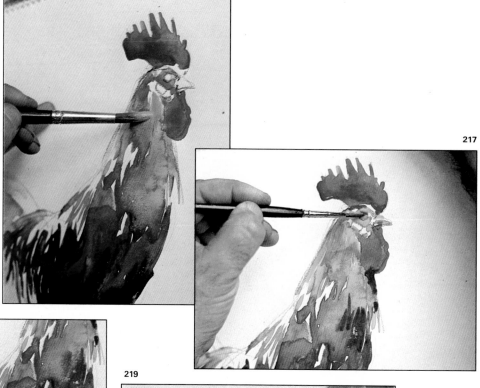

217

218

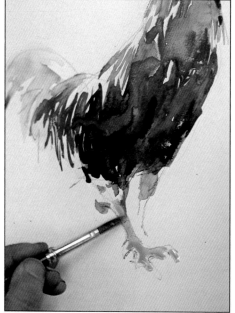

219

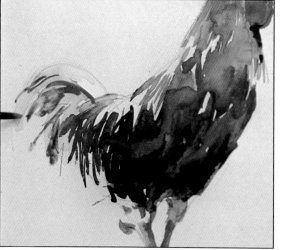

Finally, observe the finished painting of the rooster. It is a watercolor in which you can see evidence of the water, see the mixture of colors wet-on-wet, see the sharpness of those colors. You cannot help but appreciate the artist's mastery of synthesis in the way he has reserved whites in the back of the animal, in the body, under and next to the tail, so that you complete the image in your own imagination.

220

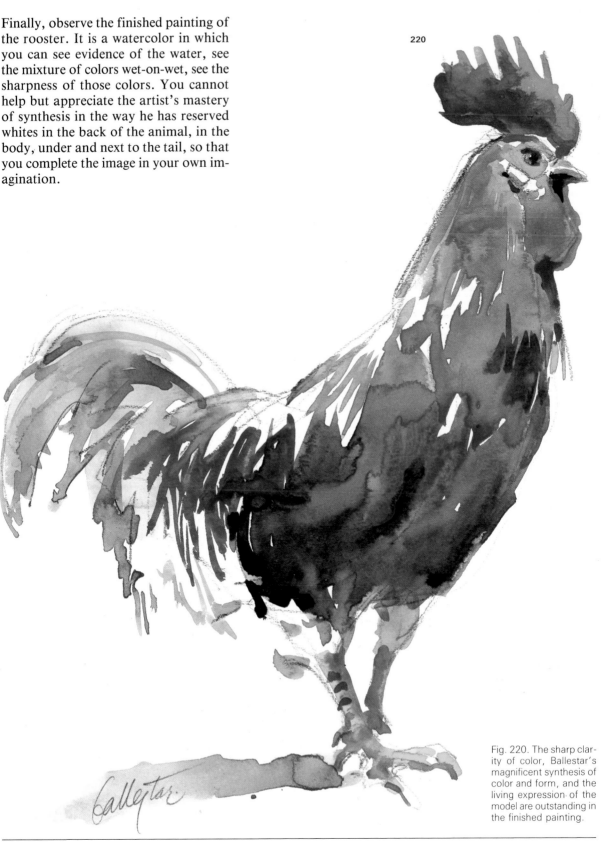

Fig. 220. The sharp clarity of color, Ballestar's magnificent synthesis of color and form, and the living expression of the model are outstanding in the finished painting.

The first practical drawing exercises in this next chapter can be done at home, or at the home of a relative or friend. Who doesn't have some friend with a pet dog, cat, or bird? Well then, you will have to go there. Then to the zoo, or to a farm. The thing is to get in front of an animal and to draw it, paint it. As an example of what you can do, and so that you can consult what we have done, Ballestar will paint various domestic animals with pencil, watercolor, and colored pencils. I will explain what he paints and how he does it. Then we will go to the zoo to complete this series of examples by drawing and painting some wild animals: a bear, a tiger, a zebra, a giraffe, a camel, and an elephant. Do it yourself! Draw and paint animals! It is incredibly interesting and a lot of fun.

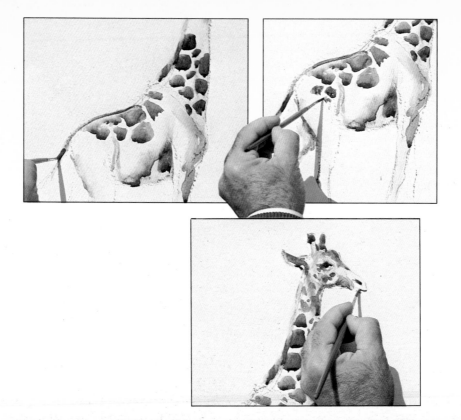

DRAWING AND PAINTING ANIMALS IN PRACTICE

Practice in drawing and painting domestic animals at home and wild animals at the zoo.

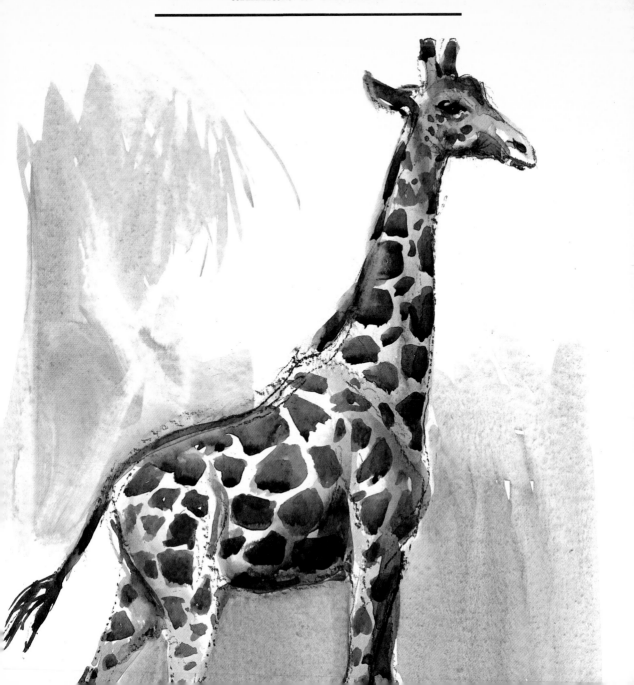

Drawing and painting animals at home

Drawing and painting at home means that you do not have to worry about anyone or anything, and that you can study, practice, make mistakes, and start over again as you wish. If this is true for you and you have a pet at home, then there is no problem. If not, do what Ballestar does and go to a friend's or relative's house.

Draw and paint a dog, yours or a relative's. First try a profile, as in Fig. 223. This view is easiest because it involves the least foreshortening. Go on to draw the animal from the front (Fig. 222). First study the head. Then, having completed a thorough study of the face, take the plunge and draw it sitting down, as we saw Ballestar doing.

Now take it one step further. Copy the head you have already drawn onto a new drawing of the dog running toward you, in a position like the one in Ballestar's drawing in Fig. 224. This means overcoming the problem of foreshortening and obtaining a score of 10 in these first practical exercises.

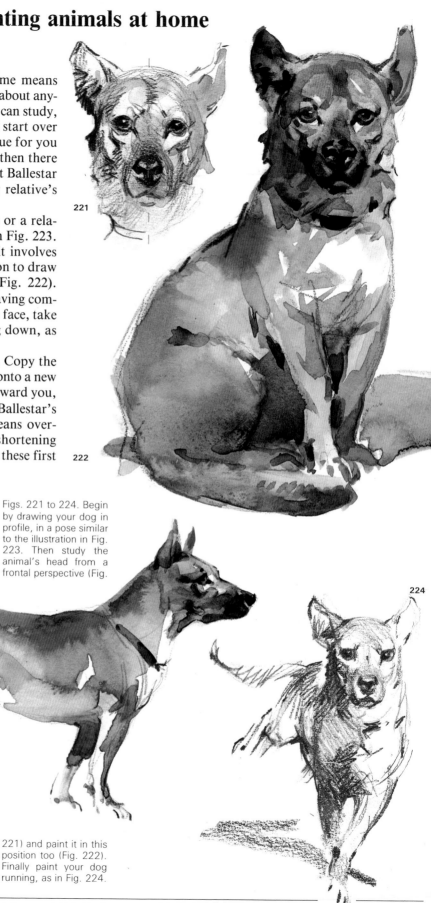

221

222

223

Figs. 221 to 224. Begin by drawing your dog in profile, in a pose similar to the illustration in Fig. 223. Then study the animal's head from a frontal perspective (Fig.

224

Ballestar

221) and paint it in this position too (Fig. 222). Finally paint your dog running, as in Fig. 224.

Parakeets

Begin by drawing them in profile, like all animals, since this way should be easiest for you. Consult the diagrams on pages 40 and 43 and remember that there are no great differences of form between birds —between a duck and an eagle, for instance. (See the parakeet drawn in profile by Ballestar in Fig. 227). Now, draw the same bird in half-profile, as in Fig. 228, and finally, from the front. Note that I am talking all the while of drawing, not of painting. Seeing structure and form is a function of drawing, and that is what you are doing over and over again in these practical exercises. Once you have mastered the form, you can then begin to paint.

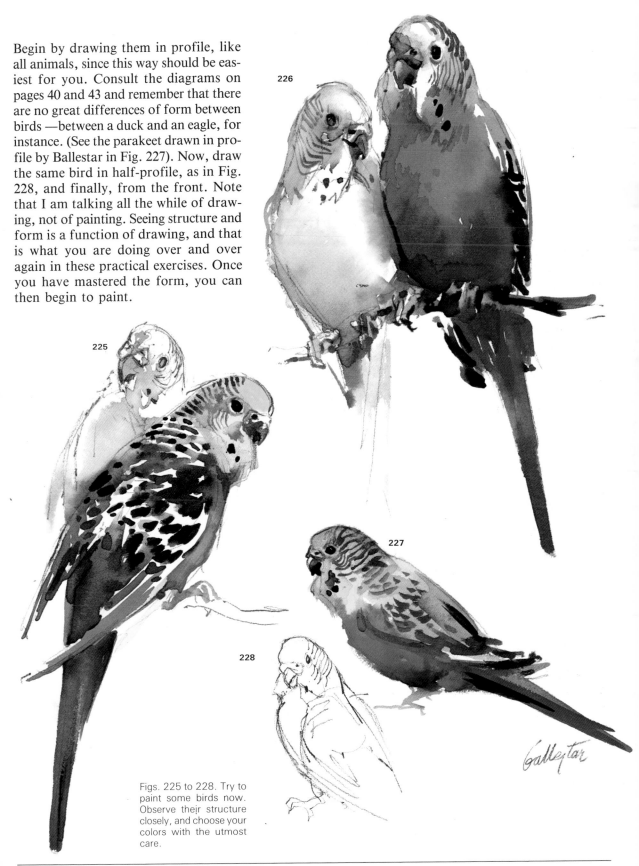

Figs. 225 to 228. Try to paint some birds now. Observe their structure closely, and choose your colors with the utmost care.

More birds in different positions

Ballestar has painted these birds in various positions: in profile, from the front, in three-quarter position, and from behind. To obtain these results, you have to stand in front of birds for a long time, observing and trying to remember basic shapes, drawing them time and time again until you capture their structure.

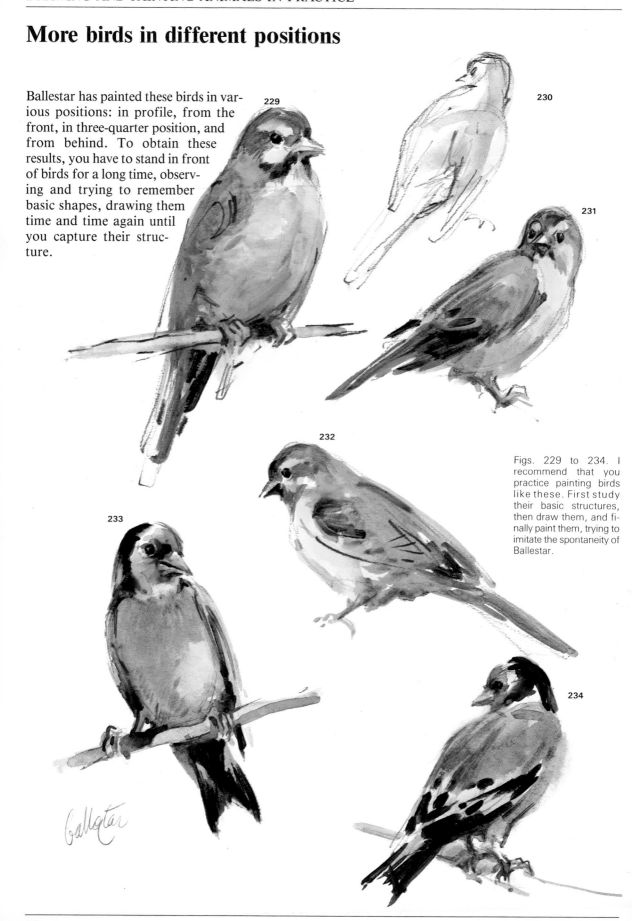

Figs. 229 to 234. I recommend that you practice painting birds like these. First study their basic structures, then draw them, and finally paint them, trying to imitate the spontaneity of Ballestar.

Cats and hamsters

Aren't they splendid, these cats painted with colored pencils? Note how, with this medium too, you can use the sgraffito effects of scraping with a razor blade. Look at the effects achieved in the whiskers and forehead of the larger head.

Finally, see the richness of color in all the animals on these pages, with superb details such as the eyes of the cat or the reserved white in the hamster.

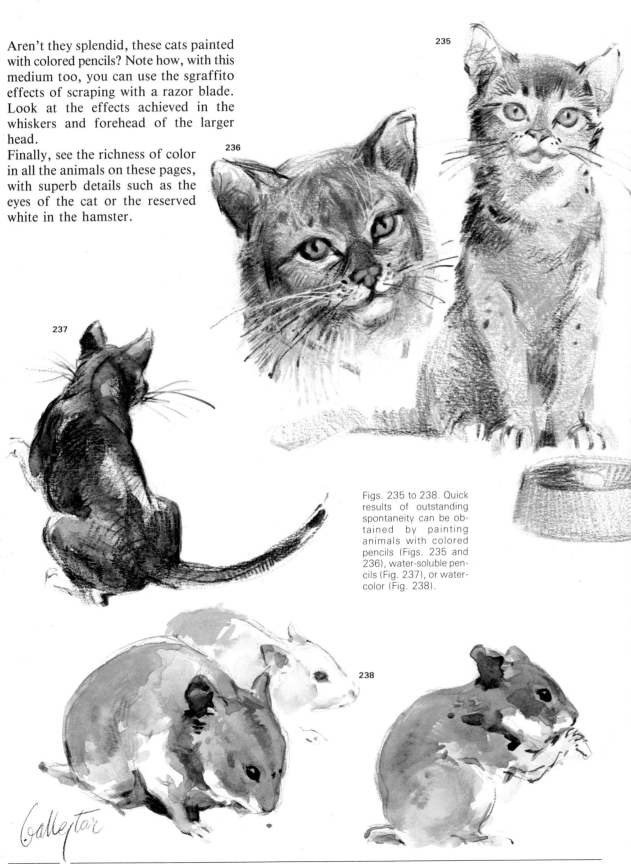

Figs. 235 to 238. Quick results of outstanding spontaneity can be obtained by painting animals with colored pencils (Figs. 235 and 236), water-soluble pencils (Fig. 237), or water-color (Fig. 238).

Drawing and painting animals at the zoo

239

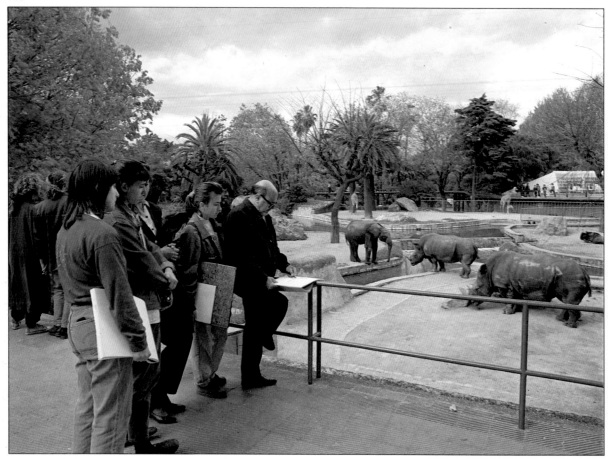

We are at Barcelona Zoo on a fine, sunny morning that has attracted quite a lot of people to come and see the animals. Ordinary people wander everywhere: couples, parents or grandparents with children, and several groups from nursery schools, accompanied by their teachers. But there are also various classes from a Fine Arts school, young men and women with their portfolios and their drawing-paper blocks under their arms, who stop to admire Ballestar's work (Fig. 239). This shows that many artists and future artists draw animals as a learning exercise, a study, or a hobby. If there is not a zoo near where you live, you can practice with domestic animals. Take a trip to the country if you can, to draw horses, cows, birds, pigs, and many more. You can also draw wild animals from photographs, but later try to visit a zoo and draw animals from real life.

Ballestar takes no more than half an hour to draw and paint each of the animals reproduced on the following pages. You can appreciate the results in the four or five sketches on the next page, completed in just a few minutes. And let me remind you that Ballestar does not need the animal to stand perfectly still in order to be able to draw it, because he always starts work with a thorough observation and study of the forms of the animal before him. Ballestar's success, as we have hinted on the preceding pages, is given to him by his knowledge of the animals' structure and his mastery in drawing them. At the risk of repeating myself, I'd like to emphasize once more that Ballestar has the ability to draw and paint animals from memory, but always with reference to poses and forms before him.

Fig. 239. Ballestar has gone to the zoo in Barcelona. While he works, a group of art students gathers to admire his extraordinary skill in drawing and painting animals.

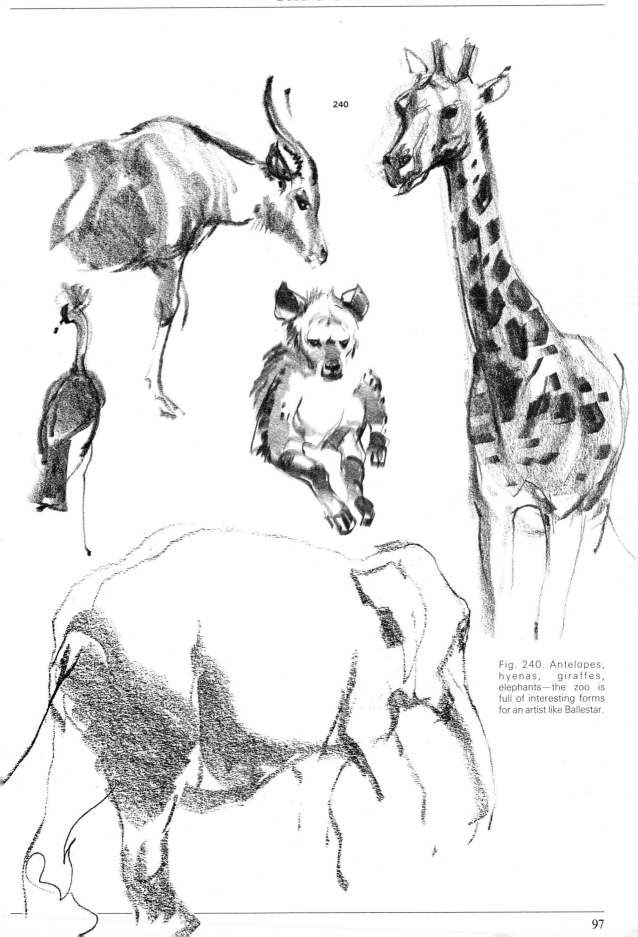

240

Fig. 240. Antelopes, hyenas, giraffes, elephants—the zoo is full of interesting forms for an artist like Ballestar.

A pen-and-ink drawing of a tiger

241

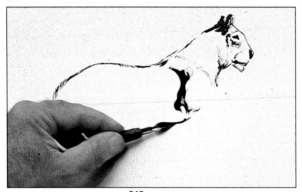

242

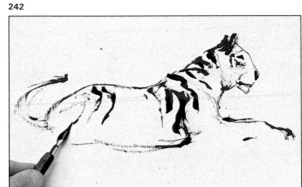

243

Figs. 241 to 245. Ballestar completed this drawing of a tiger using just a drawing pen and India ink, without the aid of a pencil or an eraser. With his pen, he draws the outline (Figs. 241 and 242), and, turning and dragging it over the paper, the stripes (Fig. 243). He uses the pen almost dry to create shadows such as those we can see in Figs. 244 and 245.

244

With an ordinary, everyday pen and India ink, Ballestar draws a tiger at the zoo. He uses no preliminary pencil outline, but plunges right in with the ink. I emphasize that it is an ordinary, everyday pen because, using only this instrument, Ballestar draws both the thinner and the thicker lines (Fig. 243) and even the scrubbing effects I have marked with the letter A in the same illustration and with a B in Fig. 244. To do this, he holds the pen inside the palm of his hand at a 90 degree angle, achieving a thin or a thick line depending on whether he holds it straight or half turned on its side. The scrubbing effects are made by rubbing with the side of the pen when it is almost dry. This drawing of a tiger, completed without the aid of pencil or eraser but using the tricks of the trade we have just mentioned, forms a real exhibition of Ballestar's artistic talent and ability.

245

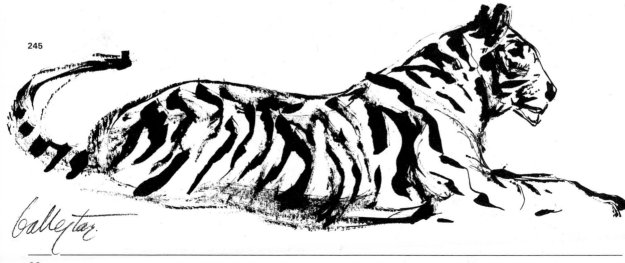

Painting a leopard in wax crayons

246

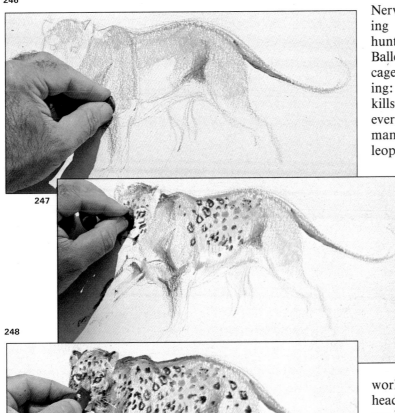

247

248

Nervous, restless, maybe hungry, walking up and down continually as if hunting—that is how the leopard acts. Ballestar sets up his easel in front of this cage and comments as he begins drawing: "He's a terrible animal, one that kills for the sake of killing and attacks everything that gets in his way, even man. It's always difficult to draw a leopard because he's a nervous animal and never stays still."

But our artist has "caught" him, as if in a photograph, drawing his crouching, tense form and painting with yellow, then sienna, sepia, and black. "I don't feel comfortable," he says. "I ought to sharpen the wax crayons and use a table to get the forms right. I'll finish it at home."

And he leaves his picture as you can see it in Fig. 248. He completes it at home in his studio, working basically on the details of the head and completing his painting as you see it in Fig. 249.

Figs. 246 to 249. Ballestar used yellow, sienna, sepia, and black wax crayons to paint this fine leopard

249

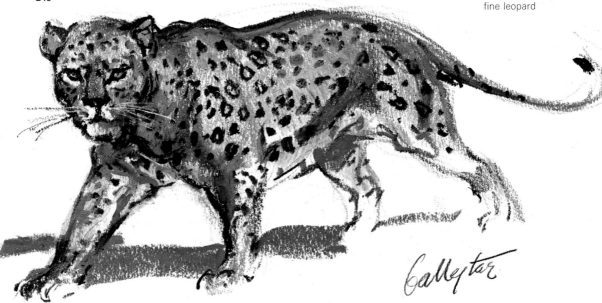

Drawing a zebra with water-soluble pencil

"It's like a pony," Ballestar says, as he draws with a 6B "dark wash" water-soluble pencil, "with the difference that the zebra has stripes."

He dilutes his initial grays with water (Fig. 250) and draws in the stripes with pencil, immediately applying water to these lines, too, as you can see in Figs. 252 and 253. And, in the same way, he completes the magnificent drawing of the zebra that you can admire in Fig. 255.

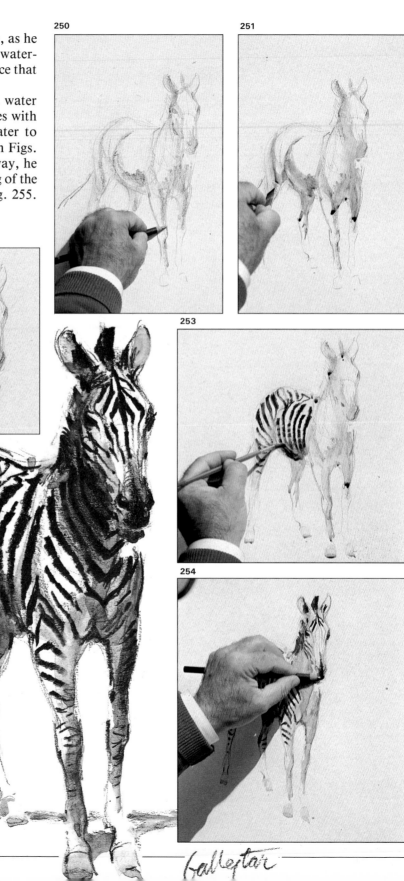

250

251

252

253

254

255

Figs. 250 to 255. Water-soluble pencil is the ideal medium for drawing an animal like this zebra, allowing the artist to express volume and draw the animal's stripes at the same time.

Ballestar

Painting a polar bear with colored pencils

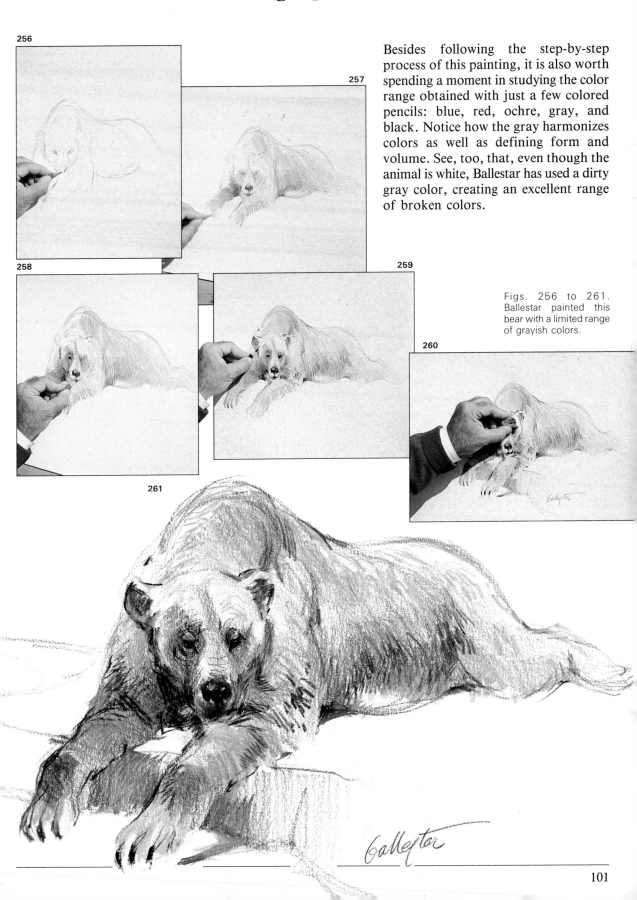

Besides following the step-by-step process of this painting, it is also worth spending a moment in studying the color range obtained with just a few colored pencils: blue, red, ochre, gray, and black. Notice how the gray harmonizes colors as well as defining form and volume. See, too, that, even though the animal is white, Ballestar has used a dirty gray color, creating an excellent range of broken colors.

Figs. 256 to 261. Ballestar painted this bear with a limited range of grayish colors.

Painting a tiger in wax crayons

The tiger in the background of the photograph came to rest here with a slow, tired walk, adopting the solemn, majestic pose of the second king of the jungle. Ballestar followed all these movements with the wax crayon in his hand, and could not help exclaiming, "My goodness, what a pose!" when he saw the animal in this classic position of feline at rest.

And he started to draw with haste, afraid of losing his chance, and then began painting with the same impatience, without a pause. First a reddish sienna gray, then a layer of yellow for the body and haunch (Fig. 264), then, straightaway, black for the features of the face and the stripes, down to the outline of the tail (Figs. 266, 267, and 268).

Just at this precise moment, the tiger lay down, letting his head droop as he closed his eyes and fell into a deep sleep. "They're like cats!" Ballestar exclaimed, carrying on painting as if nothing had happened, perfecting volume, retouching with the razor blade, reinforcing color and so on, until the picture was finally complete (Fig. 270).

262
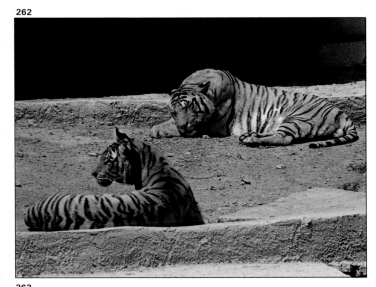

263
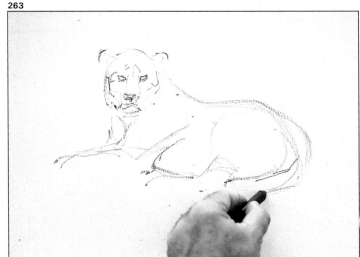

264
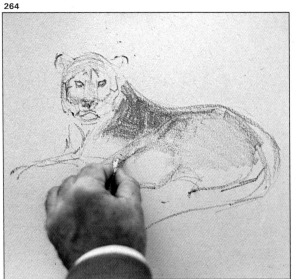

265
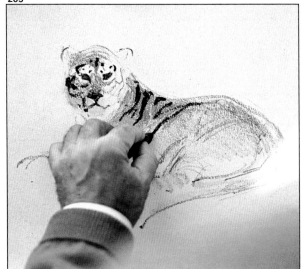

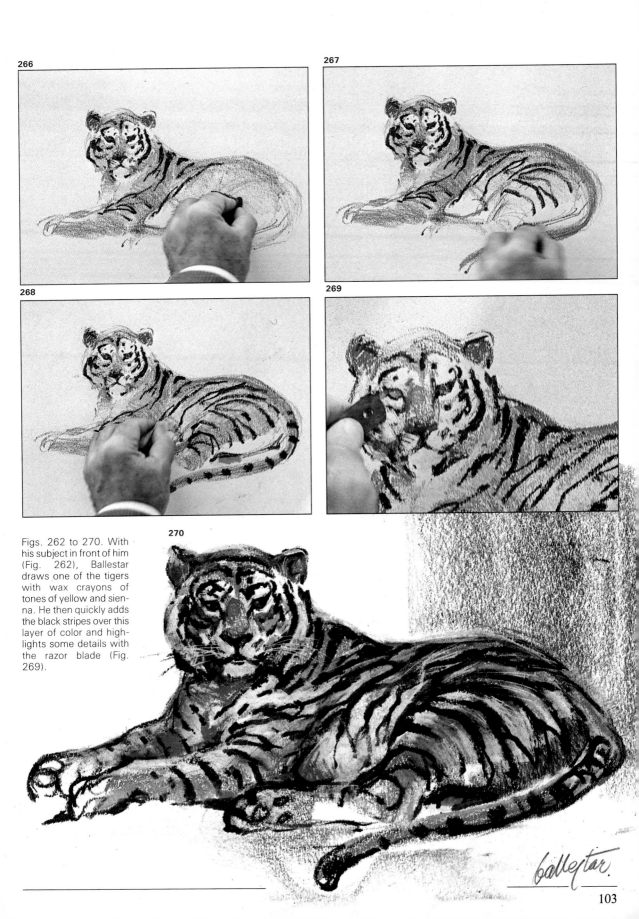

266

267

268

269

Figs. 262 to 270. With his subject in front of him (Fig. 262), Ballestar draws one of the tigers with wax crayons of tones of yellow and sienna. He then quickly adds the black stripes over this layer of color and highlights some details with the razor blade (Fig. 269).

270

Ballestar.

Painting a giraffe in watercolor

271

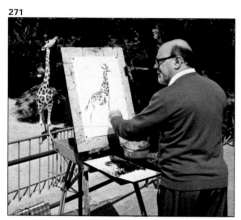

Ballestar has now brought his paint box and easel over to the giraffe enclosure. He draws the animal in front of him and immediately starts to paint, using Schoeller paper, tubes of Watteau and Talens watercolor, and a number 10 sable-hair brush with a number 4 for the smaller details. First he paints a gray-blue gouache to model the body of the animal as if the giraffe had no brown spots (Fig. 272). Then he begins to paint the spots with a mixture of burnt sienna, Vandyke brown and a little Hook-

Fig. 271. Ballestar has set up his portable easel at the giraffe enclosure and is preparing to paint the unusual shape of one of these animals using watercolor paints.

272

273

274

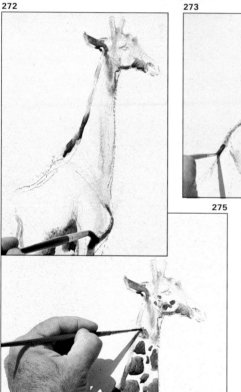

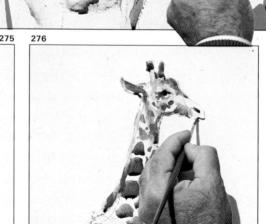

275 **276**

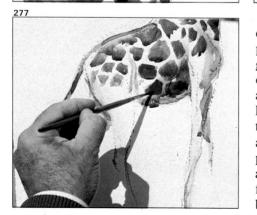

Figs. 272 to 277. This time Ballestar uses number 10 and 4 sable-hair brushes to paint on Schoeller paper, following his usual style of painting: he stains and wets the preliminary sketch (Fig. 272), then paints the animal's spots in a sienna tone, a mixture of browns and greens.

Fig. 278. The result is a perfect combination of modeled form and the play of the spots covering the body of the giraffe.

277

er's green. Note how Ballestar first paints the plain color of the spots on the giraffe's back, and then models the play of light and shade by absorbing paint and color, making the color on the back lighter. He works in the opposite way on the spots in the parts of the picture that are in shade. Ballestar then finishes the picture by painting and drawing the head at the same time (Figs. 273 to 277) and finally paints in a gray-blue background before signing his work.

278

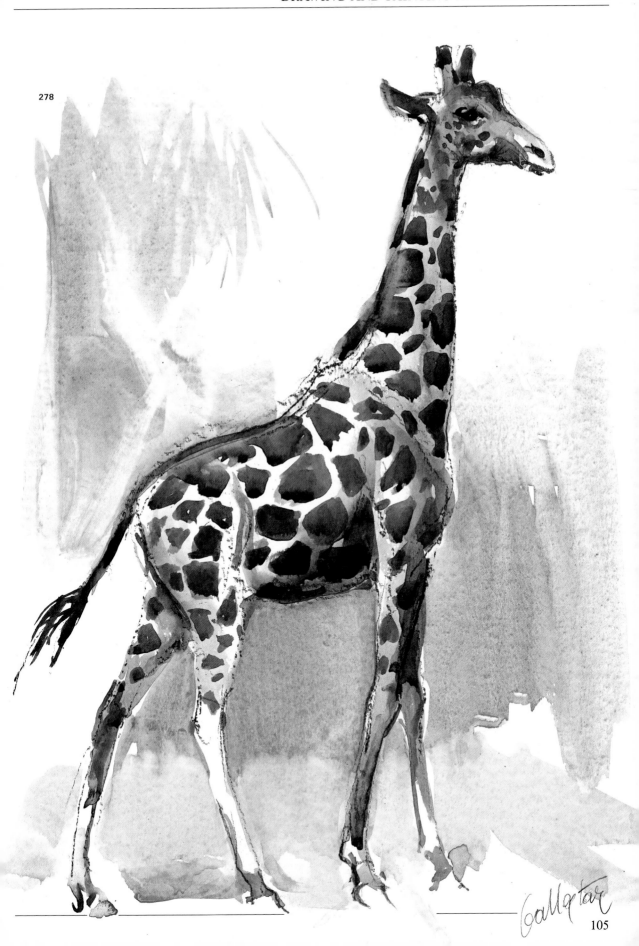

Painting a camel in watercolor

As the tiger had done before, this camel stopped in front of Ballestar, lay down, and stayed where he was without moving the whole time our artist needed to complete his painting. A woman stopped and said, "It's like a statue."

Perhaps because the camel kept his pose so perfectly, Ballestar spent longer than usual and had great fun painting, finally producing this magnificent work of form and color.

As you can see, practically the whole process was carried out using Ballestar's old synthetic-hair flat brush. The artist himself comments, "When you've been working for a long time with the same brush, you develop an affection for it and you couldn't work with any other."

Well, I would say he could, but let us get on. After drawing the camel, Ballestar paints with a mixture of siennas, oranges, and ochres, with a little ultramarine blue at the bottom of the picture (Figs. 279 to 283).

In Fig. 285, you can see how Ballestar applies the blue directly, this color then

279

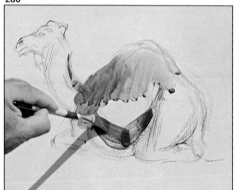

280

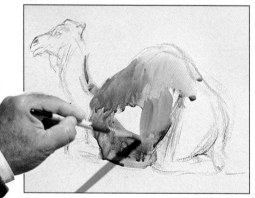

281

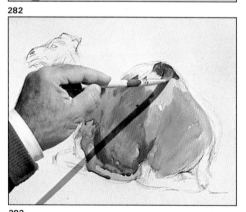

282

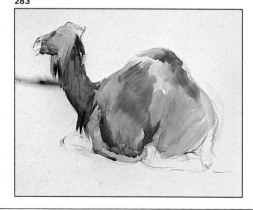

283

Fig. 279. This camel posed before Ballestar for a long time, so that the artist was able to work calmly and unhurriedly. He begins with a precise sketch and at the same time studies the harmonization of colors.

Figs. 280 to 283. With the synthetic-hair flat brush, Ballestar paints with a rich mixture of siennas, oranges, and ochres.

Figs. 284 to 289. He adds a few brushstrokes with pure blue (Fig. 285), which blends in with new tones to enrich the areas in shadow. After putting in the features of the head, he adds the finishing touches by shading in the background with a grayish tone (Figs. 288 and 289).

blending with the others in the areas of shade. How he paints the features of the face with a number 4 brush is illustrated in Figs. 286 and 287. Finally, study the finished picture (Fig. 289). See the chromatic and technical quality that Ballestar has instilled in his work—the fusion of form and color, obtained at times with the use of the wet-on-wet technique. The variety of colors did not exist in the camel but were intepreted and imagined by Ballestar.

284

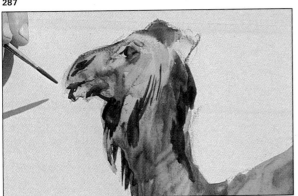

285

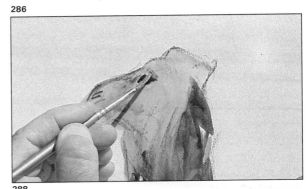

286

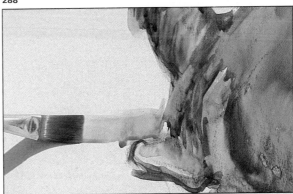

287

288

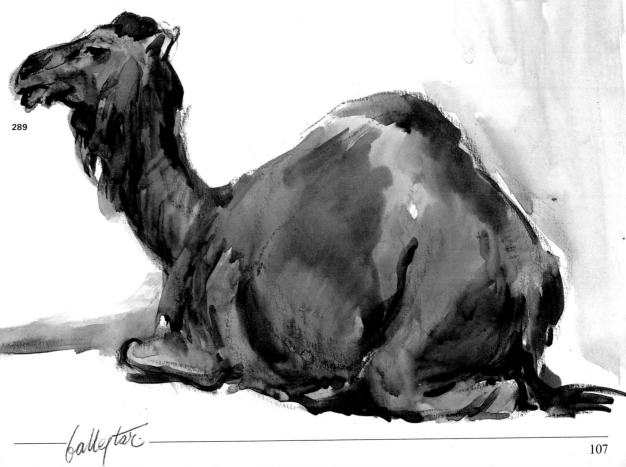

289

Painting an elephant with pastels

Ballestar's last piece for us will be an elephant at the zoo, painted with Talens Rembrandt pastels of two colors: light burnt umber and pure burnt umber. He does this painting on medium-grain Schoeller paper.

Ballestar observes, studies—taking his time, as always—and before beginning to paint with the lighter of the two pastels, says: "Not to repeat the monotony of the profile again, this time I'll paint him in three-quarter position."

The elephant will not keep still, but walks up and down slowly all the time. Ballestar is already drawing him, though, following his movements, capturing the animal in three-quarter position (Fig. 290).

The next phase consists of adding color and blending it with his fingers, adding color and blending again and again... but at the same time drawing, constructing, shading, capturing the play of light and shade, and modeling the animal's form, as in Figs. 291 to 293.

Ballestar says, thinking aloud: "The head of the elephant, the whole elephant, is like a sculpture. While I draw, I feel as if I were modeling, as if I were working with clay."

Figs. 290 to 293. Taking up his pastels, Ballestar decides to paint an elephant. Although the animal continually moves around in his enclosure, our artist portrays it in three-quarter position (Fig. 290), and begins to paint with a light sepia, filling in color (Fig. 291), blending with his fingers (Fig. 292), and harmonizing the whole picture.

290
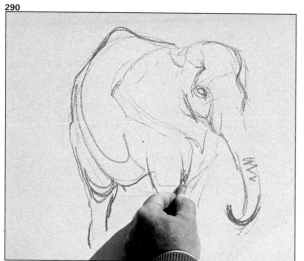

291
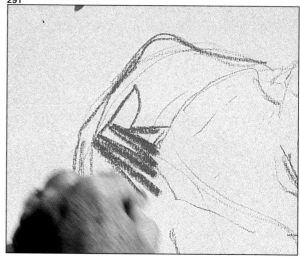

292
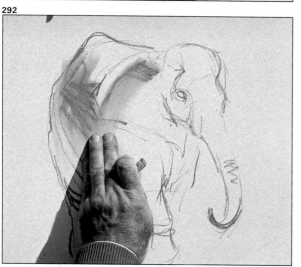

293
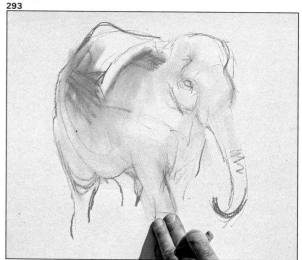

Fig. 294. With a darker burnt umber than before, he strengthens form and volume, in this case modeling the back part of the head.

Figs. 295 to 298. Ballestar highlights the line of the ear, painting a uniform color over its whole surface (Figs. 295 and 296). He also models the volumes of the head and trunk, painting and blending with ease and sureness of touch (Figs. 297 and 298).

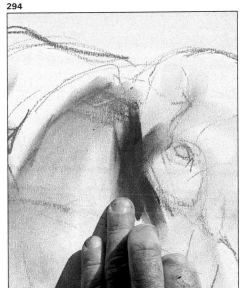

294

Ballestar combines and mixes his two colors, the lighter and the darker, drawing and modeling the ear, the forehead, the eye, the trunk... as you can appreciate in Figs. 295 to 298.

295

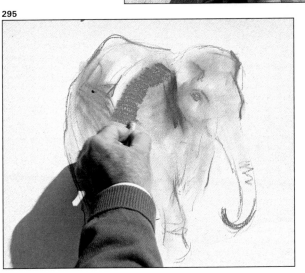

296

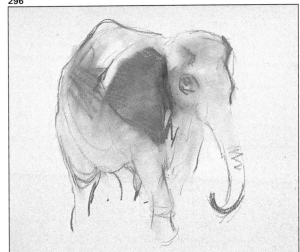

297

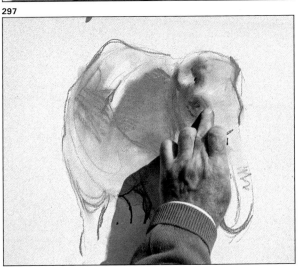

298

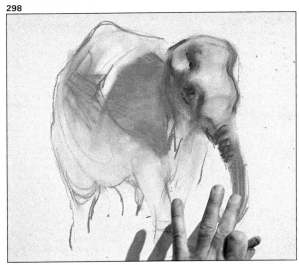

Painting an elephant with pastels

"It's going well, Ballestar," I tell him. "I'm going to reinforce, define," he replies.

And, with the darker pastel, he intensifies outlines and profiles (Fig. 299), then draws a series of lines on the body, the ear, and the trunk to depict the wrinkles so characteristic of pachyderms (Figs. 300 and 301).

"And what about the left ear?" I ask. "I can't invent that," he says; "I'll have to wait until he turns around into three-quarter position to draw it." For, of course, the elephant is moving all the time—slowly, "but it moves," as Copernicus would say.

Finally Ballestar can draw the ear. He then uses his eraser to open a light area

Figs. 299 to 301. With a darker-colored chalk, he strengthens outlines that had become faded (Fig. 299) and paints a number of loose strokes over the animal's flank and legs to suggest the texture of its skin (Figs. 300 and 301).

Fig. 302. With a rubber eraser, our artist creates highlights in the ear, the head, and the back of the animal.

Fig. 303. The finished drawing clearly shows both form and volume. Would you like to try for yourself now?

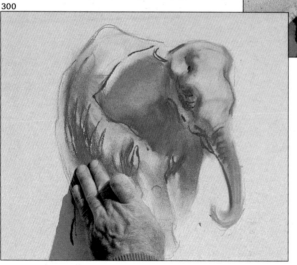

in the other ear (Fig. 302), the back, and the forehead. He finishes with a few touches: final lines in the legs and feet, and the shadow cast onto the ground by the animal.

And he signs, completing both the painting and this book. He and I both sincerely hope it will be of service to you in learning the art of drawing and painting animals.

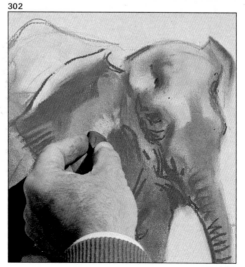